IMAGES
of America

DOVER

IMAGES of America
DOVER

Peter F. Slavin and Timothy A. Slavin

ARCADIA
PUBLISHING

Copyright © by Peter F. Slavin and Timothy A. Slavin
ISBN 978-0-7385-1565-6

Published by Arcadia Publishing
Charleston, South Carolina

Printed in the United States of America

Library of Congress Catalog Card Number: 2003109459

For all general information contact Arcadia Publishing at:
Telephone 843-853-2070
Fax 843-853-0044
E-mail sales@arcadiapublishing.com
For customer service and orders:
Toll-Free 1-888-313-2665

Visit us on the Internet at www.arcadiapublishing.com

Contents

Acknowledgments		6
Introduction		7
1.	Special Events	9
2.	Loockerman Street	21
3.	Military	35
4.	Fire and Police	47
5.	Farms	57
6.	Schools	67
7.	Business and Industry	79
8.	Around Town	89
9.	Churches	107
10.	A Capital City	113

ACKNOWLEDGMENTS

This volume has been a labor of love. The more than 200 historical photographs in this volume were chosen from thousands of images. Being able to leaf our way through history, photograph by photograph, is an honor and a privilege.

We owe a tremendous debt of gratitude to the staff of the Delaware Public Archives, including Joanne Mattern, Heather Jones, Randy Goss, Lori Hatch, Dawn Mitchell, Cynthia Caldwell, Michele Peterson, Valda Perry Hoennicke, Chris Darling, and Terence Burns. Their professionalism to the archival profession is unmatched, and their knowledge of Delaware's history and historical records is, in itself, a state treasure.

Finally, we dedicate this work to our parents, Katherine and Joseph Slavin. It is through their hard work and parenting that two brothers came to enjoy the spoils of history and writing.

INTRODUCTION

Dover—Delaware's capital, in law and in spirit—has a long and storied history. Originally laid out by William Penn in 1683, the city maintains its strong ties to the colonial and revolutionary period through an impressive program of historic preservation and interpretation. The Green in Dover remains one of the most beautiful and historically significant sites in all of Delaware.

This small volume of photographs is no substitute for a true history of Dover. These photographs will not provide a narrative history, and this compilation is in no way a complete history of Dover.

What these photographs will offer, however, is a sense of wonder and imagination. By their very nature, photographs give us an evocative image of a single moment in time. The photograph serves to launch streams of memories about people, places, and events. Historical photographs have another compelling quality—they break down traditional barriers to history. People from multiple generations and races can gather around a single image and share memories. Looking at historical photographs also requires no formal education or degrees; it is, quite simply, history at its purest.

The historical photographs contained in this volume share a common characteristic: they are each a public record. Culled from the rich collection of the Delaware Public Archives, these photographs are available to any citizen, for any purpose, at any time. They are a natural resource.

It is important to remember that for much of the period in which these photographs were taken—the early 20th century—photography was a relatively new and complicated science. Equipment was large, fragile, and expensive. Film and film processing were both dangerous and harmful. In short, those who practiced this new craft were small in number.

One such first generation photographer was Roydon Hammond. Hammond relocated to Delaware from Maine after being hired as a seed analyst for the Board of Agriculture. As part of his agricultural work, Hammond took detailed photographs of seed development. His photographic equipment and skills were extraordinary. Soon after starting to work for the Board of Agriculture, Hammond's skills were called upon to take photographs to help promote Delaware. More than 2,000 such photographs now exist in the Delaware Public Archives, many of which are used in this volume.

Whether taken by a professional or an amateur, the historical photographs in this volume are gathered here to tell a history. This history is episodic and incomplete, and it is designed as such. The memories and reminiscences of those who view these historical photographs provide the true history of Dover.

One

Special Events

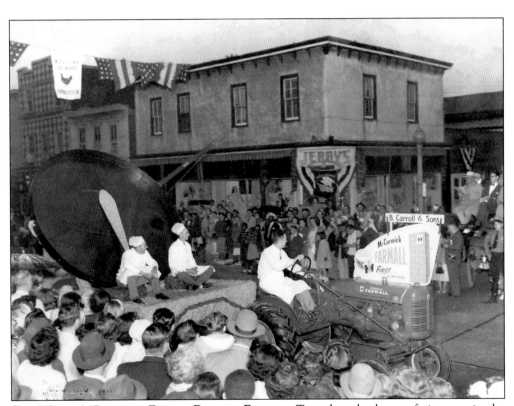

THE WORLD'S LARGEST FRYING PAN ON PARADE. Touted as the largest frying pan in the world, this over-sized cast iron skillet was assembled and used annually at the Delmarva Chicken Festival. Here, the skillet serves as a parade attraction on board the Delaware Poultry Improvement Association's float during the 1950 Delmarva Chicken Festival parade down Loockerman Street. (Delaware Public Archives, Purnell Photograph Collection, Dover, Box 3, Folder 5.)

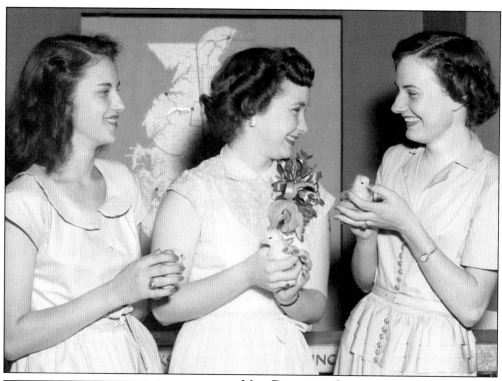

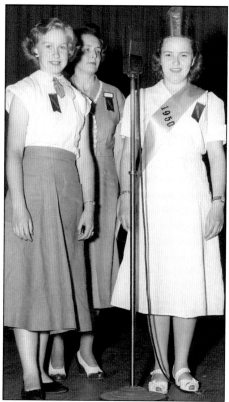

MISS DELMARVA CONTEST, CAPITAL THEATER, DOVER, 1950. Three finalists share a light moment at the event, part of the Delmarva Chicken Festival. The contestants were judged according to their beauty, posture, poise, and personality. The Queen received her choice of $500 cash, or a $750 scholarship to the college she attended. From left to right are the following: Lois Sard, Miss Maryland; Joan Lynch, Queen Delmarva III, Miss Delaware; and Virginia Hook, Miss Virginia. (Delaware Public Archives, General Photograph Collection, Local Events, Box 1 Folder 7.)

FINALISTS, JUNIOR CHICKEN COOKING CONTEST, 1950. The event was held at Social Hall, Dover High School on June 15. Contestants were judged on taste, appearance, originality, economy, and time. Pictured from left to right are the following: Joanne Brown, runner-up; unidentified; and event champion Eleanor Clark of Easton, Maryland. Clark received a $250 cash prize for her victory. The contest was one of the highlights of the Delmarva Chicken Festival held in Dover. (Delaware Public Archives, General Photograph Collection, Local Events, Box 1 Folder 7.)

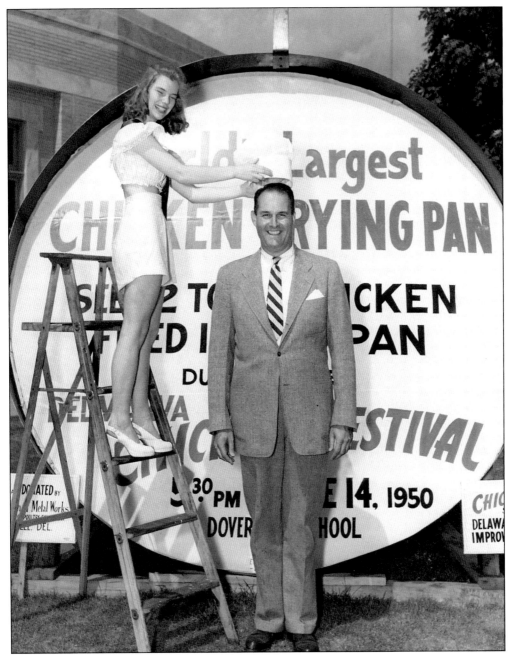

DELMARVA CHICKEN FESTIVAL, 1950. 1949 Miss Delmarva Jane Mustard and former governor Elbert N. Carvel are shown standing next to the world's largest frying pan. (Delaware Public Archives, General Photograph Collection, Local Events, Box 1 Folder 6.)

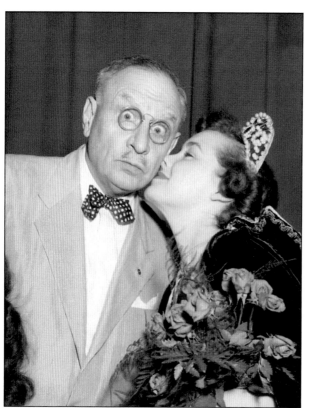

KISS FROM A BEAUTY QUEEN. Radio personality Hilma Baukage receives a surprise kiss from Joan Lynch, Queen Delmarva III. The beauty contest was one of many events held at the 1950 Delmarva Chicken Festival and was broadcast live on WDOV, Dover. (Delaware Public Archives, General Photograph Collection, Local Events, Box 1 Folder 7.)

LIVE BROADCAST FROM DOVER, WOR RADIO. Gov. Bert Carvel is shown being interviewed during the 1950 Delmarva Chicken Festival. (Delaware Public Archives, General Photograph Collection, Local Events, Box 1 Folder 7.)

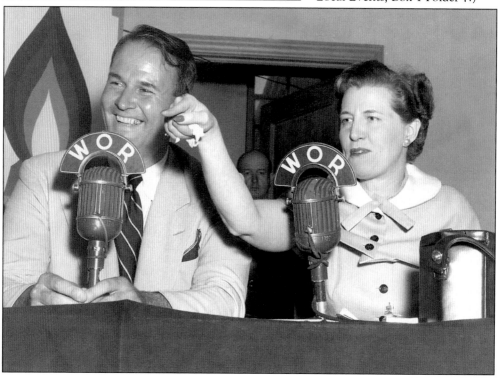

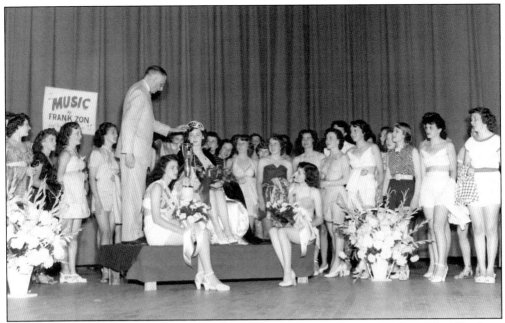

CROWNING THE QUEEN, DELMARVA CHICKEN FESTIVAL. Radio personality Hilma Baukage crowns Queen Delmarva III, Joan Lynch, at the 1950 event. (Delaware Public Archives, General Photograph Collection, Local Events, Box 1 Folder 7.)

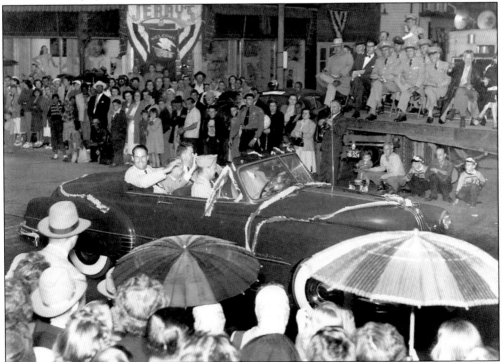

GOVERNOR CARVEL AT THE DELMARVA CHICKEN FESTIVAL PARADE, 1950. Crowds lining Loockerman Street greet Governor Carvel during the parade. (Delaware Public Archives, General Photograph Collection, Local Events, Box 1 Folder 6.)

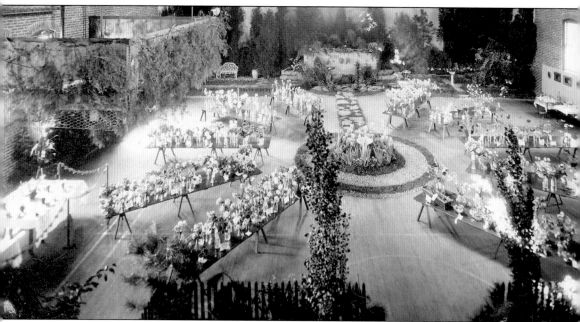

FLOWER SHOW AT OLD DOVER DAYS, N.D. The flower show sponsored by the Dover Garden Club was held in the State Armory building. Old Dover Days continues this tradition with a garden tour held throughout the Old Dover Days weekend. (Delaware Public Archives, General Photograph Collection, Local Events: Dover Days, Box 2 Folder 4.)

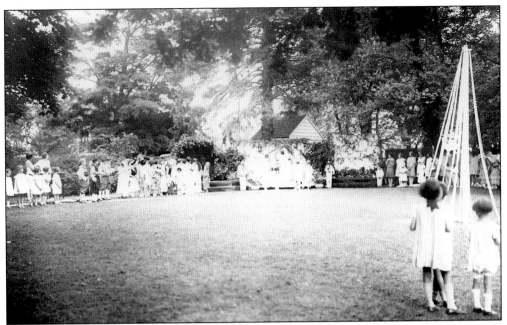

"MAY FETE" AT THE CHRIST EPISCOPAL CHURCH YARD, MAY 28, 1929. This photograph may well be the first picture of the first Old Dover Days, founded in 1928. Maypole dancing at the Christ Episcopal Church continues to this day on the first Saturday of every May. (Delaware Public Archives, State Board of Agriculture Photographs, Negative 998.)

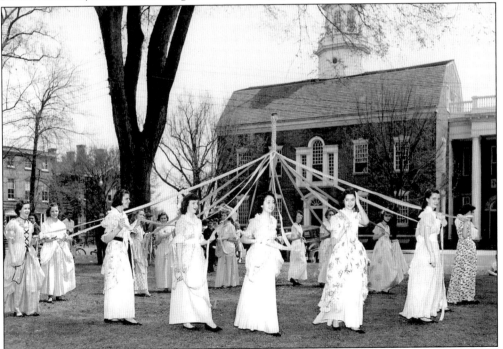

MAYPOLE DANCE, THE GREEN, C. 1950. The junior high girls perform a Dover Days' tradition, dancing around the Maypole. (Delaware Public Archives, General Photograph Collection, Local Events: Dover Days, Box 1 Folder 12.)

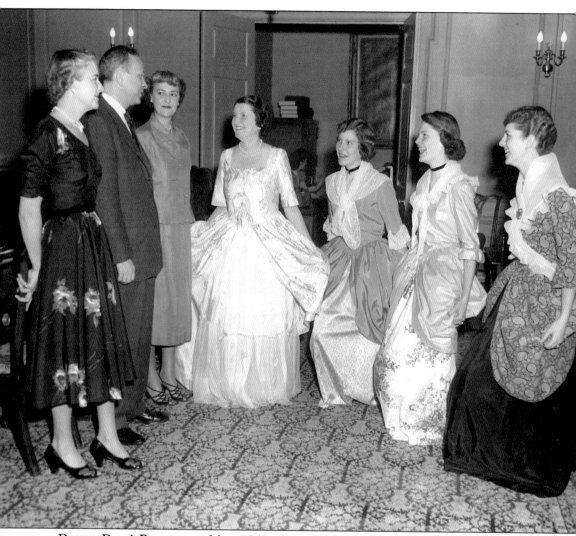

DOVER DAYS' RECEPTION, MAY 1953. Gov. Caleb Boggs and his wife greet Dover Days' hostesses in his office at Legislative Hall. (Delaware Public Archives, General Photograph Collection, Local Events: Dover Days, Box 1 Folder 8.)

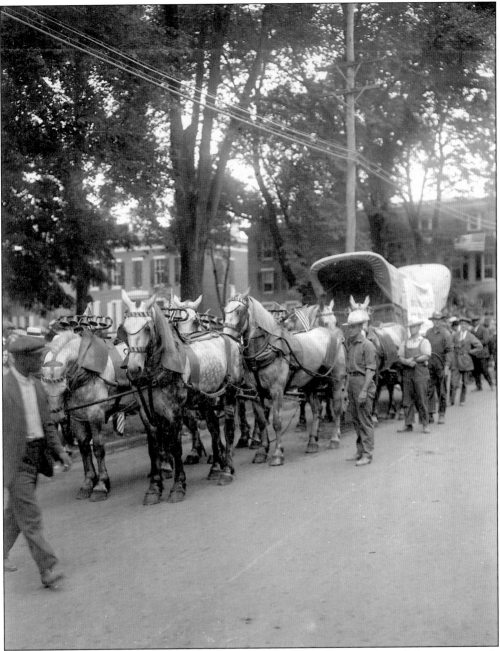

OPENING THE DUPONT HIGHWAY, 1924. An old powder wagon is one of the many parade attractions during the dedication ceremonies marking the opening of the DuPont Highway. The dedication took place on July 2, 1924. (Delaware Public Archives, State Board of Agriculture Photographs, Negative 188.)

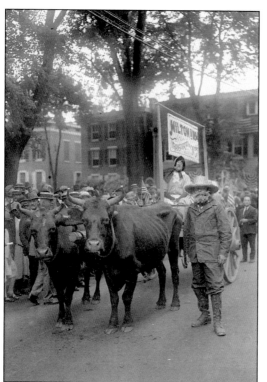

OX CART ON PARADE, 1924. An ox cart on parade on the Green during the DuPont Highway dedication, July 2, 1924. The "woman" driving the ox cart—actually a man in costume—is smoking a corncob pipe. (Delaware Public Archives, State Board of Agriculture Photographs, Negative 191.)

A SILVER MAP, 1924. At a ceremony in Dover, T. Coleman DuPont receives a silver map of Route 13 in recognition of his gift of DuPont Boulevard (also known as Route 13) to the state. More than 70 years later, the map was discovered in a closet by then Secretary of State William Quillen; the map now hangs in the foyer of the Buena Vista historic home on DuPont Boulevard in New Castle. (Delaware Public Archives, General Photograph Collection, Local Events, Box 2 Folder 8.)

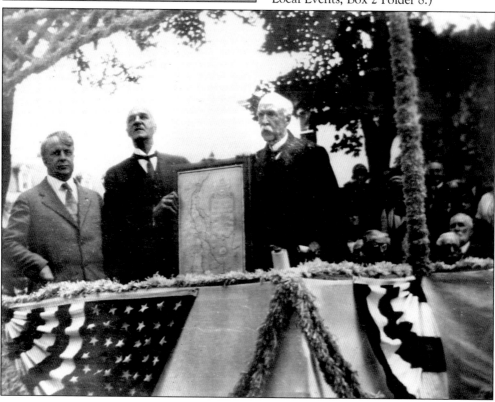

1903 FORD AND 1907 FORD, 1924. The cars are on The Green during DuPont Highway dedication, July 2, 1924. (Delaware Public Archives, State Board of Agriculture Photographs, Negative 186.)

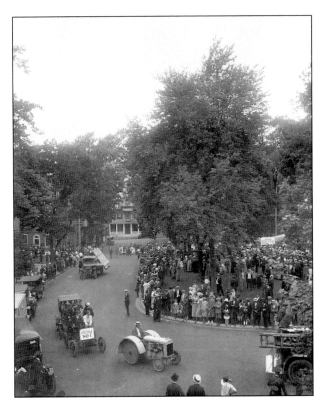

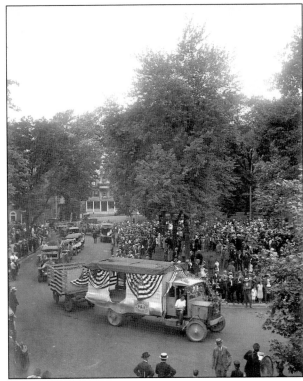

PENINSULA AUTO EXPRESS WAGON, 1924. The wagon is parked on The Green during DuPont Highway dedication, July 2, 1924. (Delaware Public Archives, State Board of Agriculture Photographs, Negative 185.)

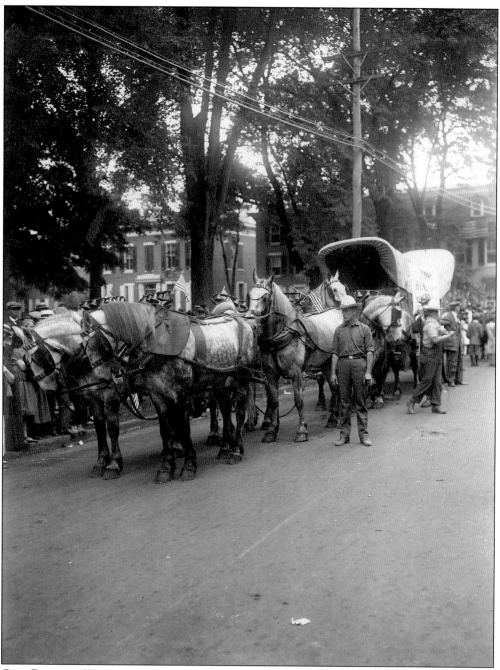

OLD POWDER WAGON, 1924. This photograph was taken during the DuPont Highway dedication, July 2, 1924. (Delaware Public Archives, State Board of Agriculture Photographs, Negative 189.)

Two

LOOCKERMAN STREET

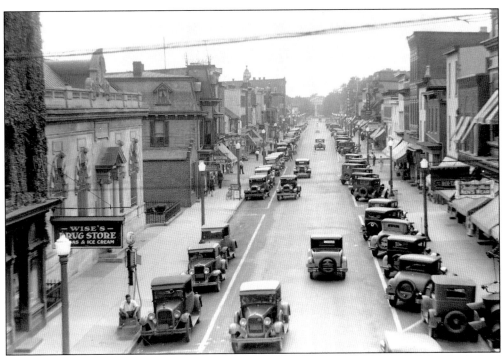

LOOCKERMAN STREET, SATURDAY AFTERNOON, 1929. Reflecting Dover's role as the hub of commerce in the area, and Loockerman Street's historic role in the retail corridor, this early street scene photograph was taken from the old Post Office at the corner of Loockerman and State Streets on August 10, 1929. In the lower left corner is Wise's Drug Store, which included a curbside gas pump. (Delaware Public Archives, State Board of Agriculture Photographs, Negative 1037.)

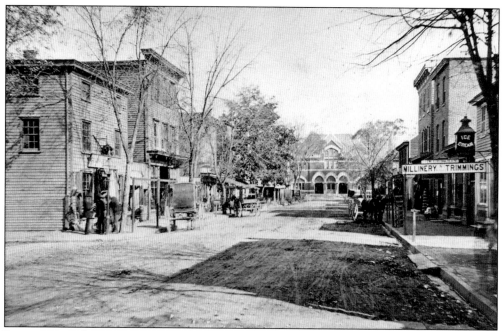

LOOCKERMAN STREET FROM BRADFORD STREET, LOOKING EAST, N.D. This early photograph depicts Loockerman Street prior to being paved for automobile traffic. The building at the end of Loockerman Street is the Old Post Office. (Delaware Public Archives, General Photograph Collection, Cities and Towns, Box 1 Folder 3.)

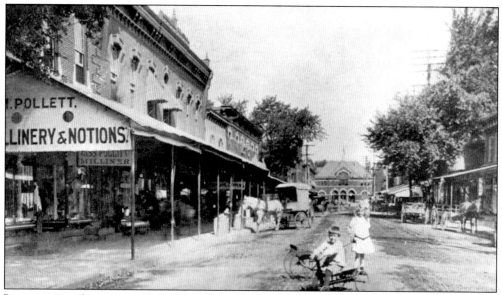

LOOCKERMAN STREET, C. 1900. This photograph presents another view of Loockerman Street, replete with "Pollett's Millinery and Notions" and horse carriages. The covered sidewalks on the north side of Loockerman Street are no longer in existence. (Delaware Public Archives, General Photograph Collection, Cities and Towns, Box 1, Folder 4.)

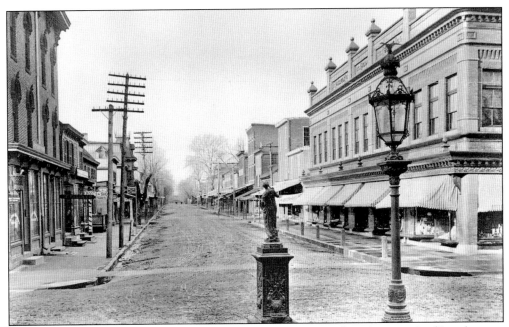

LOOCKERMAN STREET FROM THE OLD POST OFFICE, N.D. Another photograph of Loockerman prior to paved roads depicts the grandeur of the Priscilla Block Building on the right. The building sits at the corner of Loockerman and State Street and was spared from demolition in the 1990s through the intervention of city and state officials. (General Collections, Cities and Towns, Box 1 Folder 4.)

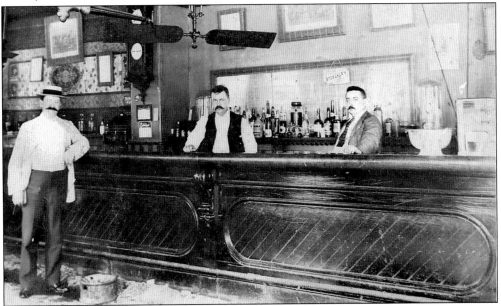

BAYARD HOTEL, LATE 1800S. Sitting at the corner of Governor's Avenue and Loockerman Street, the Bayard Hotel was originally converted from a private home. The hotel boomed with the opening of a rail station and in the 1880s, rooms rented for $1.50 per day. Frank VanSant is shown tending bar in the middle of the picture. (Delaware Public Archives, General Photograph Collection, Business and Industry, Box 1 Folder 5.)

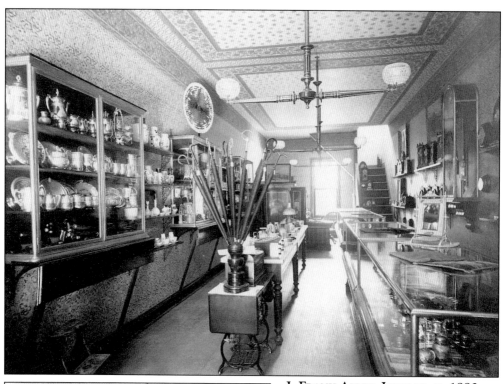

J. Frank Allee, Jeweler, c. 1880. J. Frank Allee Jewelers occupied 103 Loockerman Street throughout the 1880s and into the 1890s on the site of the former Delaware Trust Company building. (Delaware Public Archives, General Photograph Collection, Business and Industry, Box 1 Folder 5.)

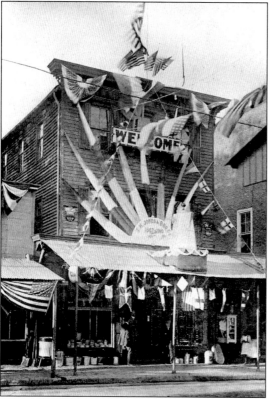

T.K. Jones and Brothers Company, 1910. T.K. Jones was located in the downtown area from 1867 until 1910 and specialized in groceries and sundry goods. (Delaware Public Archives, General Photograph Collection, Business and Industry, Box 1 Folder 8.)

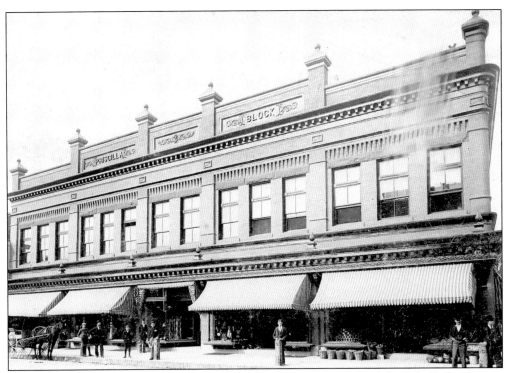

PRISCILLA BLOCK BUILDING, C. 1900. The building was originally built by A.B. Richardson in 1898 and has housed a grocery store, fashion store, and restaurant. (Delaware Public Archives, Janson Collection, Folder 4.)

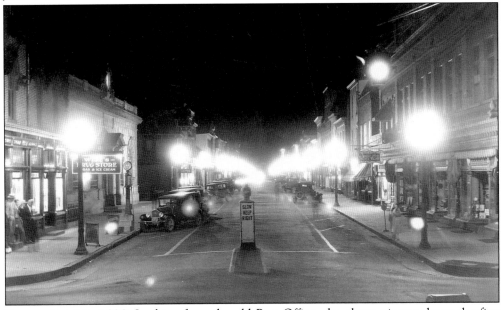

STREET LIGHTS, 1928. Looking from the old Post Office, the above picture shows the first night of gas street lights on Loockerman Street. The advent of the automobile and streetlights promised to modernize downtown Dover. (Delaware Public Archives, General Photograph Collection, Cities and Towns, Box 1 Folder 4.)

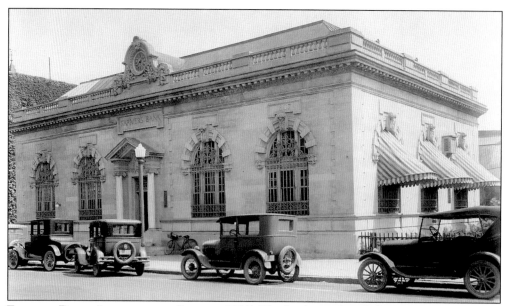

FARMERS BANK, LOOCKERMAN STREET, 1927. The bank was founded in 1807, and served as Dover's only bank through the first half of the 19th century. The original location of the first branch was at Bank Lane and The Green. At the time, the only cashier was required to live in the building with his family. The bank built this building in 1927. It is now the location of Citizen's Bank. (Delaware Public Archives, General Photograph Collection, Business and Industry, Box 1 Folder 6.)

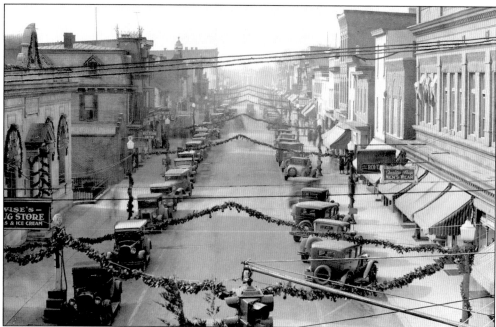

LOOCKERMAN STREET WITH CHRISTMAS DECORATIONS, DECEMBER 9, 1929. Christmas lights on Loockerman Street remain a tradition to this day. The City of Dover sponsors the Festival of Lights, which includes more than 70,000 lights lining Loockerman Street through the holidays. (Delaware Public Archives, State Board of Agriculture Photographs, Negative 1079.)

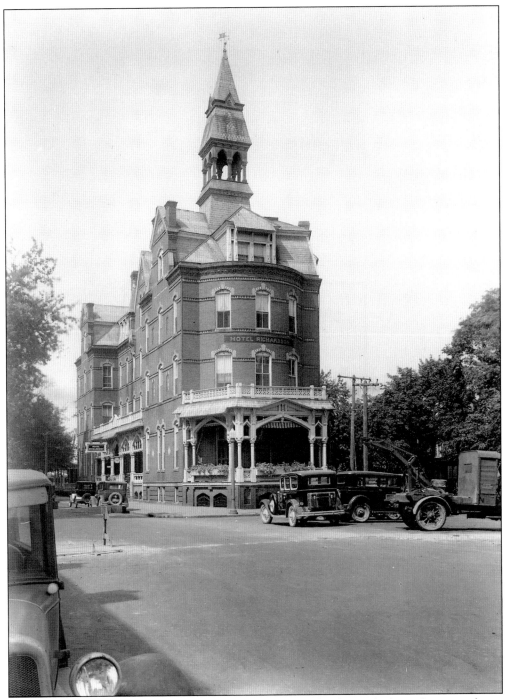

HOTEL RICHARDSON, AUGUST 13, 1929. In all its splendor and glory, the magnificent Hotel Richardson served as a hub of activity for traveling businessmen and legislators. This photo, taken from the corner of State Street and Loockerman Street looking north, shows the grand porch, replete with flowerboxes. (Delaware Public Archives, State Board of Agriculture Photographs, Negative 1041.)

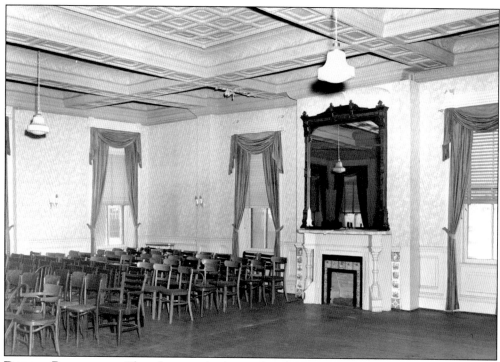

DINING ROOM, N.D. The photograph shows the dining room of the Hotel Richardson, shortly before the hotel closed and was later demolished. (Delaware Public Archives, General Photograph Collection, Business & Industry, Box 1 Folder 7.)

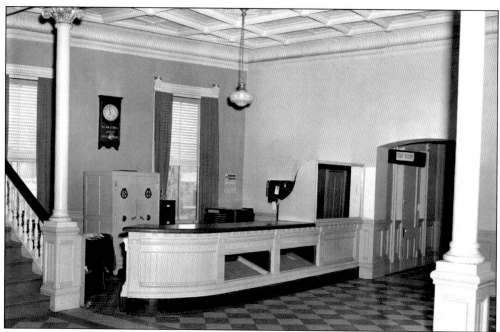

LOBBY, N.D. Here lies the grand lobby of the Hotel Richardson, just prior to demolition. (Delaware Public Archives, General Photograph Collection, Business & Industry, Box 1 Folder 7.)

LOOCKERMAN STREET, C. 1880. Horse-drawn carriages are seen lining the busy downtown district. (Delaware Public Archives, Purnell Photograph Collection, Places, Box 3, Folder 13.)

BUTZ PROPERTY, LOOCKERMAN STREET, DECEMBER 22, 1928. The Butz property was located on Loockerman across from Bradford Street at the current location of Forney's Jewelry Store. (Delaware Public Archives, State Board of Agriculture Photographs, Negative 957.)

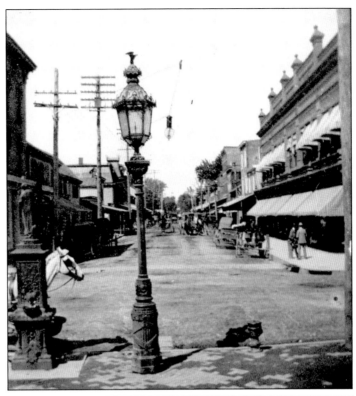

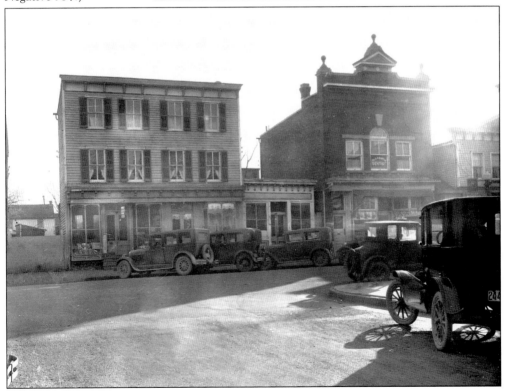

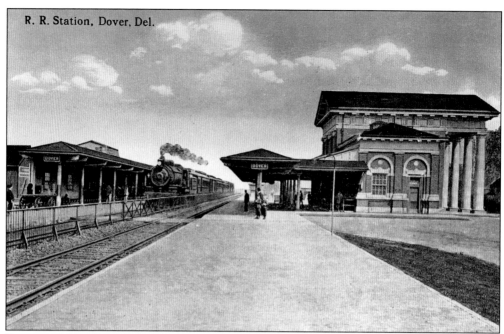

Pennsylvania Railroad Station, c. 1910, Architectural Rendering of the Railroad Station in Dover, n.d. The station was recently rehabilitated and houses state government offices; during the rehabilitation workers discovered a trove of historical records from the train station which are currently housed at the Delaware Public Archives. (Delaware Public Archives, Purnell Photograph Collection Box 3 Folder 10.)

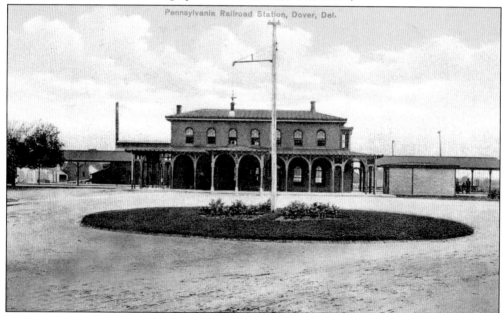

Pennsylvania Railroad Station, c. 1910. Situated at the west end of Loockerman Street, the Railroad Station was a major transportation hub until the 1920s. The opening of the DuPont Highway in 1917 is considered to be one of the factors in the sharp decline in passenger rail traffic. (Delaware Public Archives, Post Card Collection, #55375.)

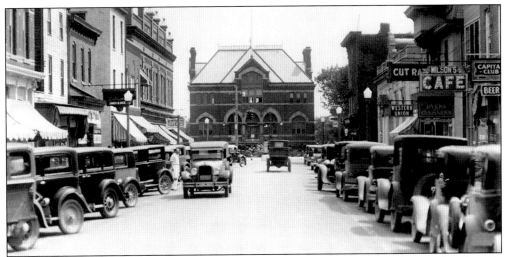

MOVING THE OLD POST OFFICE, 1933. The moving of the Old Post Office on October 19, 1933 in Dover was a major event and started efforts to develop the east side of Dover. The building was placed on railroad rails and moved with the help of mules to a new location further down Loockerman Street. (Delaware Public Archives, State Board of Agriculture Photographs, Negative 1603.)

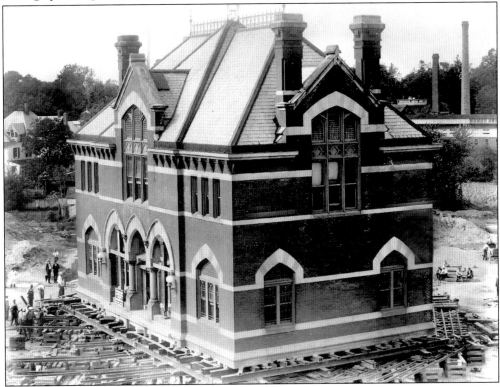

OLD POST OFFICE ON RAILS, 1933. These series of photographs show the Old Post Office in mid-move. The building was not only moved a considerable distance down Loockerman Street, but also turned so that the front door faced south. (Delaware Public Archives, State Board of Agriculture Photographs, Negative 1619.)

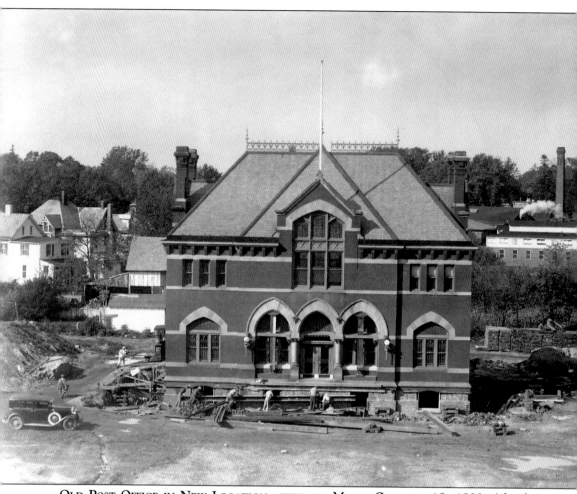

OLD POST OFFICE IN NEW LOCATION AFTER ITS MOVE, OCTOBER 19, 1933. After being placed in its new location, the Old Post Office is secured to its foundation. (Delaware Public Archives, State Board of Agriculture Photographs, Negative 1607.)

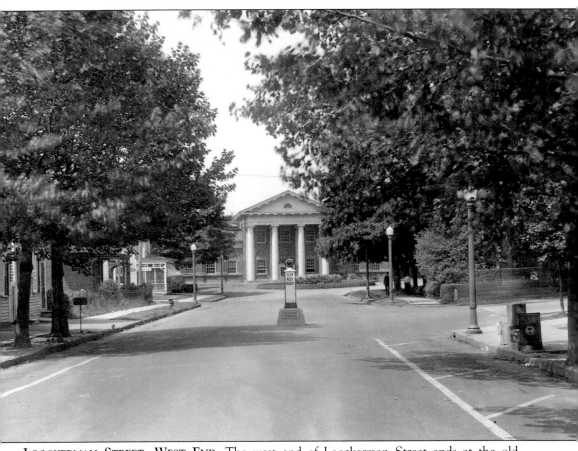

LOOCKERMAN STREET, WEST END. The west end of Loockerman Street ends at the old railroad station. Plans are underway to restore the traffic circle and continue the development of Loockerman Street.

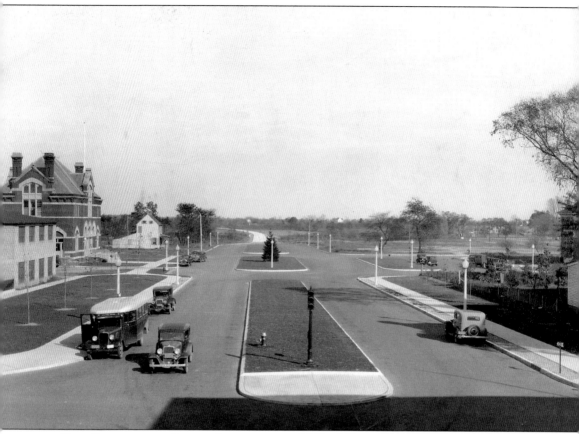

EAST LOOCKERMAN STREET EXTENSION, C. 1930S. When the Old Post Office was moved, a new extension of Loockerman Street was built to the east. This new extension is now one of the most heavily traveled streets in the downtown. The Old Post Office is visible on the left, in the new location, where it was rehabilitated and served as City Hall. (Delaware Public Archives, General Photograph Collection, Cities and Towns, Box 1 Folder 3.)

Three

MILITARY

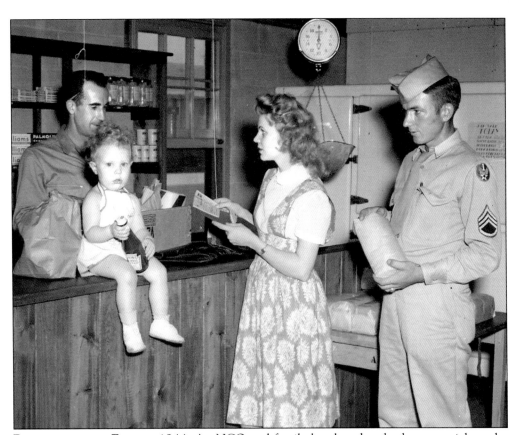

BUYING FOR THE FAMILY, 1944. An NCO and family buy bread and other essentials at the Dover Army Air Field sales commissary on September 9, 1944. The wife, pictured above, is purchasing the goods with ration coupons. (Department of State, Delaware in World War II, Military Home Front, Box 1 #1-22.)

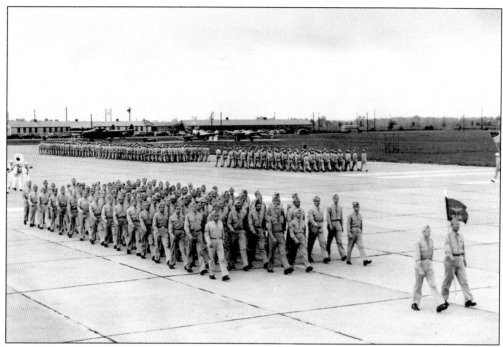

ON PARADE, C. 1946. These parade exercises held at the Dover Army Air Base provide evidence of the number of troops serving on the base. Throughout World War II, the base trained fighter pilots for combat in P-47 Thunderbolts. (Department of State, Delaware in World War II, Military Home Front, Box 1, #103-126.)

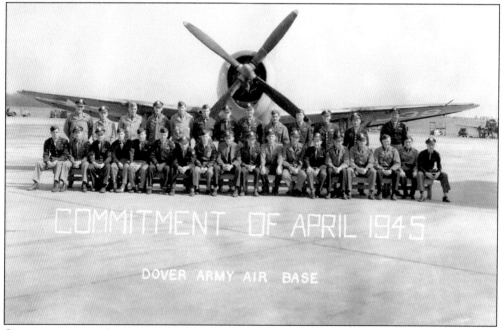

COMMITMENT OF APRIL 1945, DOVER ARMY AIR BASE. "Commitment photos" such as these provided both officers and enlisted men an opportunity to send home a photograph. (Department of State, Delaware in World War II, Military Home Front, Box 1, #85-102.)

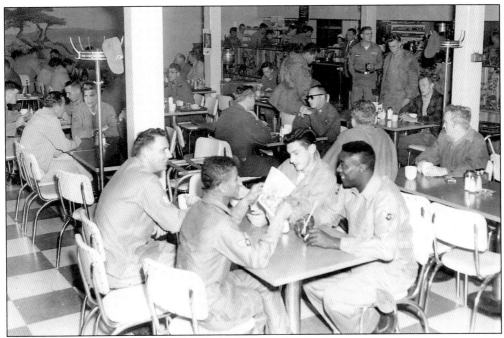

COMMISSARY, C. 1946. The commissary, located on the Air Base, was a primary gathering spot for service men and women. (Department of State, Delaware in World War II, Military Home Front, Box 1, #43-63.)

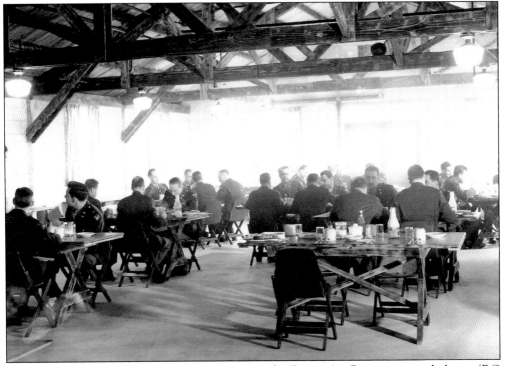

OFFICER'S MESS, C. 1946. The officer's mess at the Dover Air Base is pictured above. (RG 1325.206, Box 1 23-42.)

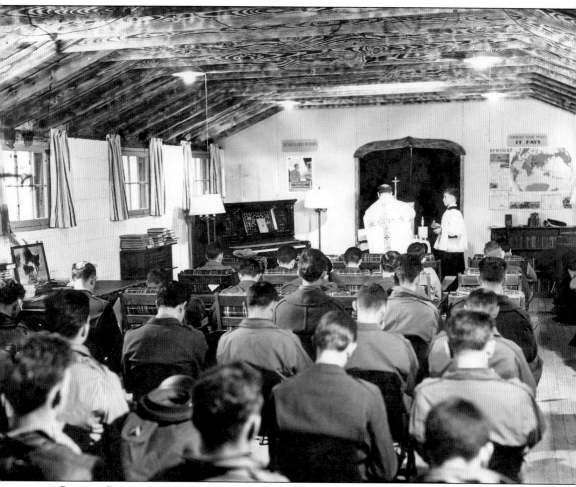

CHAPEL SERVICE, C. 1946. An impromptu chapel service is held in the library on the Air Base. One of the little-known activities to take place at the Dover Army Air Base was the development of airborne rockets. Specialists from across the country worked at the base in order to develop, test, and deploy these rockets. (Department of State, Delaware in World War II, Military Home Front, Box 1, #1-22.)

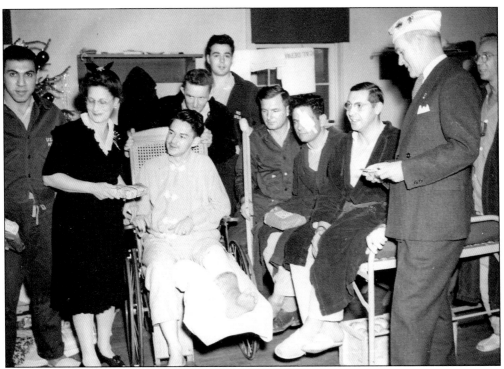

CHRISTMAS, 1944, DOVER AIR FIELD. Injured soldiers celebrate the holidays at a party sponsored the American Legion. A few short years prior, the base site was a public airport owned by the city of Dover. The city government leased the site to the Army at the outset of World War II. (Department of State, Delaware in World War II, Military Home Front, Box 1 #23-42.)

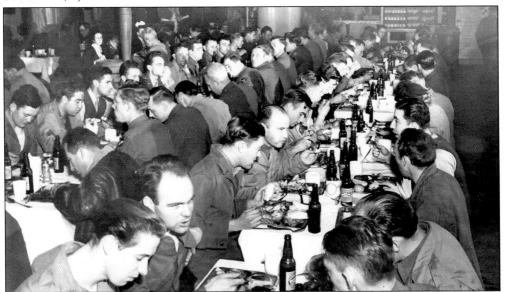

CHRISTMAS DINNER, 1944. Tin trays and bottled beer crowd the table as soldiers join in the holiday spirit with a Christmas dinner in the SQ H. Mess Hall. (Department of State, Delaware in World War II, Military Home Front, Box 1, #23-42.)

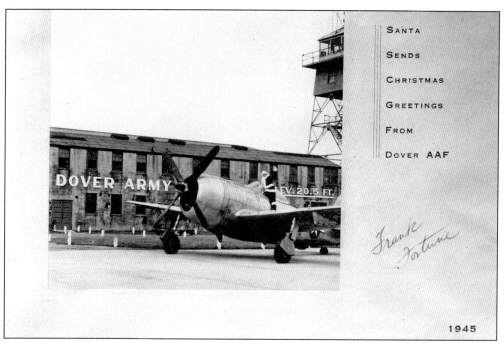

SEASON'S GREETINGS, DOVER ARMY AIRFIELD, 1945. Many soldiers sent this postcard home to send loved ones some holiday cheer. Notice the sign indicating the airfield was at 20.5 feet elevation, an indication of the base's proximity to the Delaware Bay. (Department of State, Delaware in World War II, Military Home Front, Box 1, #1-22.)

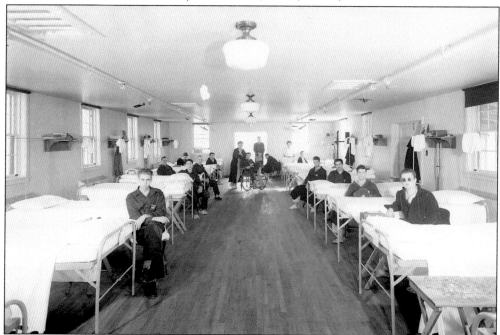

HOSPITAL WARD, 1944. Soldiers rest while recovering from wounds at the Dover Army Air Base, March 1, 1944. (Department of State, Delaware in World War II, Military Home Front, Box #1 23-42.)

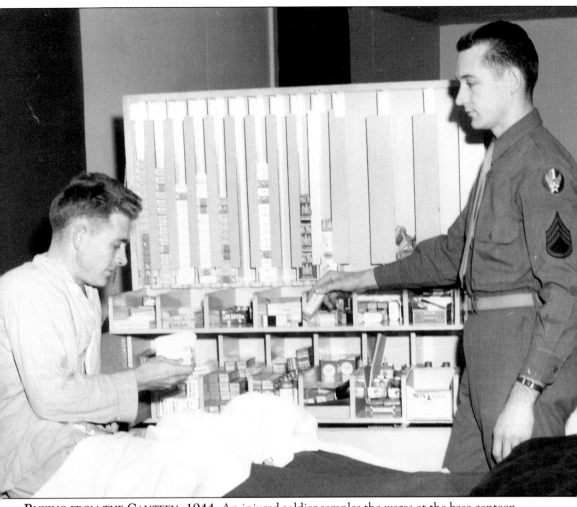

BUYING FROM THE CANTEEN, 1944. An injured soldier samples the wares at the base canteen. Items for sale included Lifesavers, Chiclets, cigarettes, and playing cards. (Department of State, Delaware in World War II, Military Home Front, Box #1 2-42.)

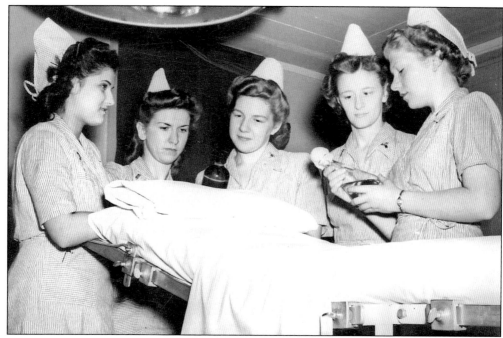

NURSES ON DUTY, DOVER AIR FIELD, JANUARY 31, 1945. The nurses at the air base provided invaluable service to the sick and injured service men and women. (Department of State, Delaware in World War II, Military Home Front, Box 1, #23-42.)

AMERICAN RED CROSS—DELAWARE CHAPTER, DOVER, 1959. During World War II, the organization played an active role at Dover Army Air Base. The Gray Ladies, a service of the American Red Cross, were sent to various military hospitals throughout the state. Their duties included shopping, writing mail, and contacting relatives for injured soldiers. (Delaware Public Archives, Purnell Photograph Collection, Box 3 Folder 1.)

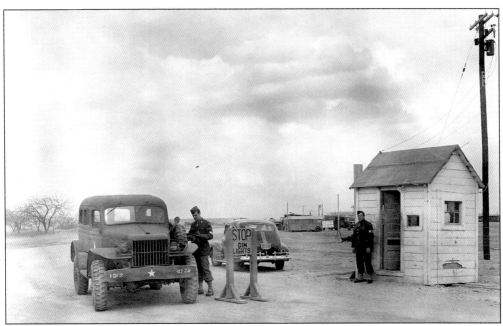

MILITARY POLICE BOOTH ENTRANCE, C. 1946. This early photograph shows the booth entrance to the base. (Department of State, Delaware in World War II, Military Home Front, #43-63.)

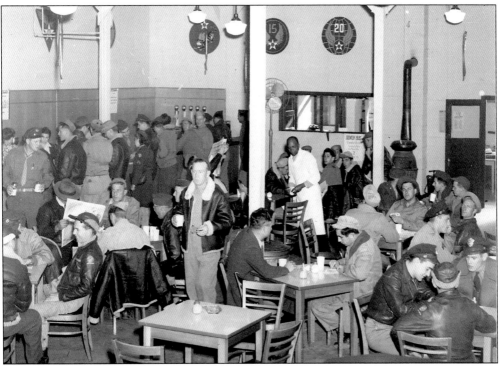

MESS HALL DINNER, NOVEMBER 9, 1944. The mess hall included a coal stove (right) and a sign offering bus rides into downtown Dover. (Department of State, Delaware in World War II, Military Home Front, Box #1 43-63.)

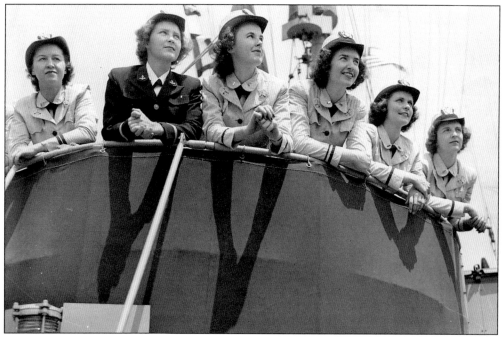

DOVER RESIDENT RETURNS, WORLD WAR II, N.D. Lt. J.G. Ruth Schiller of Dover (fourth from left) smiles as she returns to the Philadelphia Navy Yard. (Delaware Public Archives, Purnell Photograph Collection Box 3 Folder 7.)

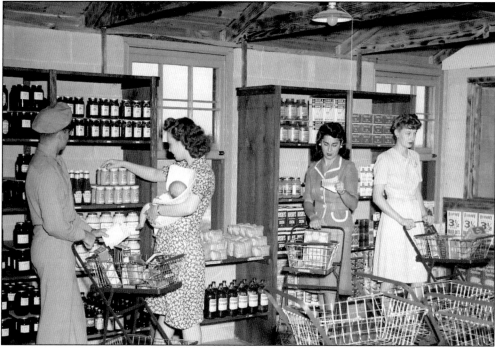

ARMY WIVES AT THE SALES COMMISSARY, C. 1944. Items stocked on the shelves included rolled oats, cocoa, flour, ketchup, and Spam. (Department of State, Delaware in World War II, Military Home Front, Box #1 1-22.)

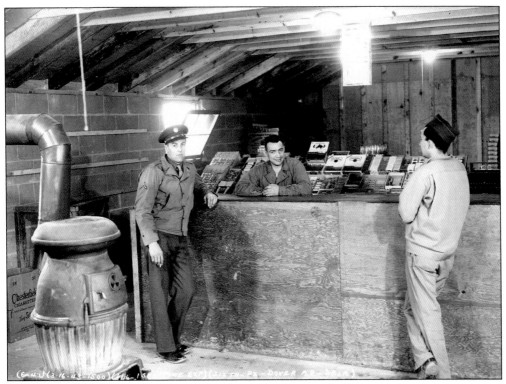

INSIDE THE BASE EXCHANGE, C. 1946. An early photograph shows the base exchange used by soldiers to buy a variety of goods. Today, the Dover Air Force Base Exchange is a modern facility serving thousands of families attached to the base. (Department of State, Delaware in World War II, Military Home Front, Box 1 #43-63.)

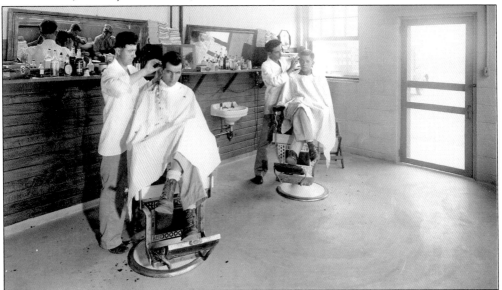

HAIRCUTS, 1944. Two servicemen partake in an age-old military tradition—the haircut—at the base barber shop. (Department of State, Delaware in World War II, Military Home Front, Box #1, 43-63.)

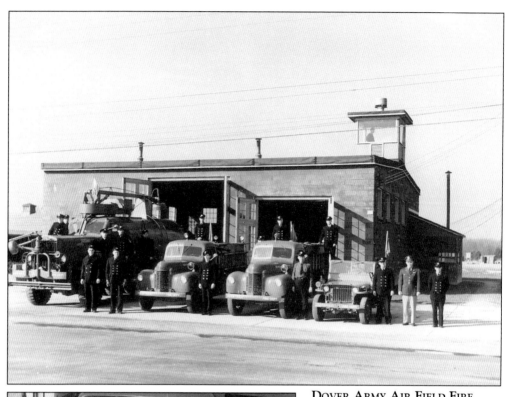

DOVER ARMY AIR FIELD FIRE STATION, JANUARY 23, 1946. Fire protection on the Air Base was (and remains) a concern for base officials. Fire crews received special training on jet fuel and crash recovery. (Department of State, Delaware in World War II, Military Home Front, Box #1 1-22.)

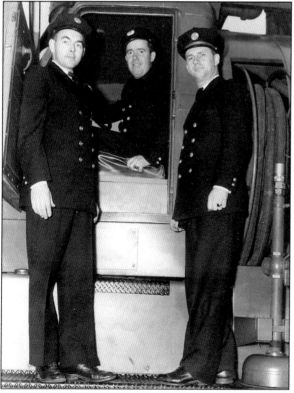

FIRE CREW, JANUARY 23, 1946. Members of the Dover Air Force Base fire department pose for a picture. (Department of State, Delaware in World War II, Military Home Front, Box 1, #1-22.)

Four
FIRE AND POLICE

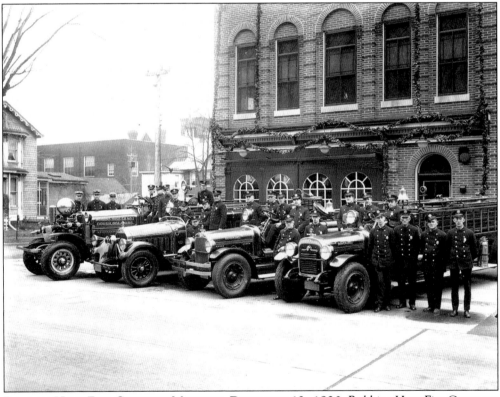

ROBBINS HOSE FIRE COMPANY MEMBERS, DECEMBER 13, 1930. Robbins Hose Fire Company is the only volunteer fire company to serve a capital city in the country. The original fire brigade, which pre-dated the company, was started by the city in the 1860s. The brigade was tested by two large fires—the Wilmington Conference Academy (now Wesley College) in 1876 and the Capitol Hotel in 1879. In 1882, 17 men contributed $1 a piece to initiate the Robbins Hose Company, named for Thomas C. Robbins, who was a benefactor to the early fire brigades. (Delaware Public Archives, State Board of Agriculture Photographs, Negative 1201.)

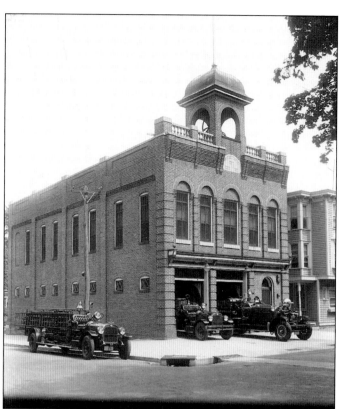

ROBBINS HOSE FIRE COMPANY, AUGUST 8, 1929. Robbins Hose Company Station Number One sits at the corner of Governor's Avenue and Reed Street. A second station was built in the 1990s to serve the west side of Dover. (Delaware Public Archives, State Board of Agriculture Photographs, Negative 1017.)

ROBBINS HOSE FIRE COMPANY MEMBERS, DECEMBER 13, 1930. The twenty-four members of the Robbins Hose Company pose in dress uniforms. (Delaware Public Archives, State Board of Agriculture Photographs, Negative 1202.)

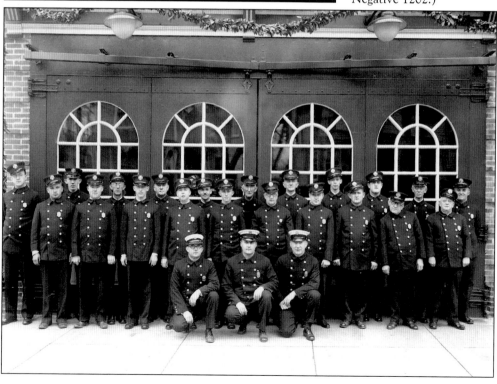

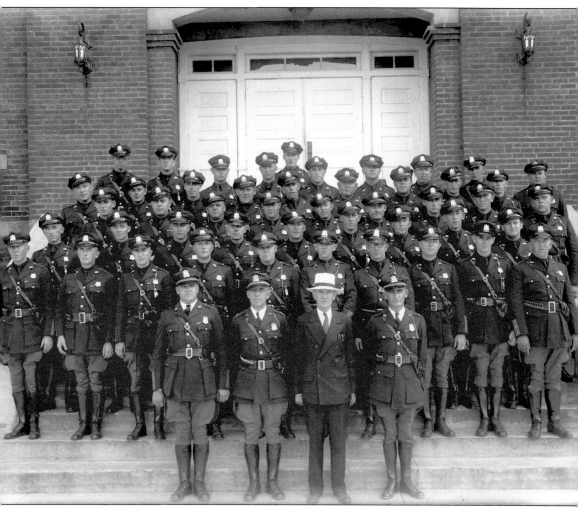

STATE HIGHWAY POLICE GROUP IN DOVER, SEPTEMBER 1, 1931. In 1919, Governor Townsend authorized the creation of a traffic patrol under the authority of the State Highway Commission. This patrol was the forerunner to the Delaware State Police and would later be charged with responsibility for all rural districts in Delaware. This group photo shows the Delaware State Police on the steps of the State House. (Delaware Public Archives, State Board of Agriculture Photographs, Negative 1272.)

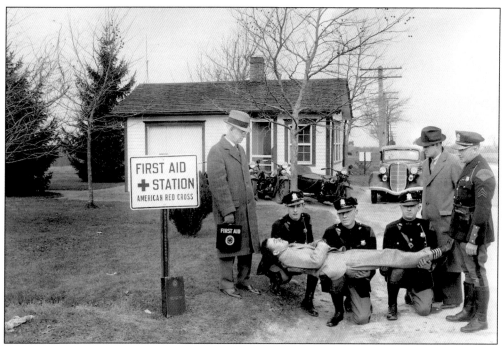

FIRST AID STATION, C. 1930. This first aid station was established at the State Police Station. State policemen received training in how to resuscitate and transport patients. (Delaware Public Archives, State Board of Agriculture Photographs, Negative 1945.)

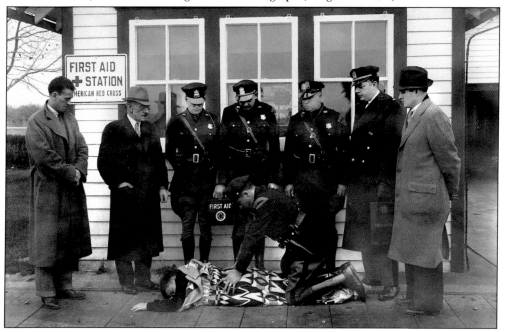

FIRST AID STATION, C. 1930. The American Red Cross promoted the use of First Aid Stations and such new techniques as resuscitation, which is depicted. Many of these new techniques were used during World War I. (Delaware Public Archives, State Board of Agriculture Photographs, Negative 1946.)

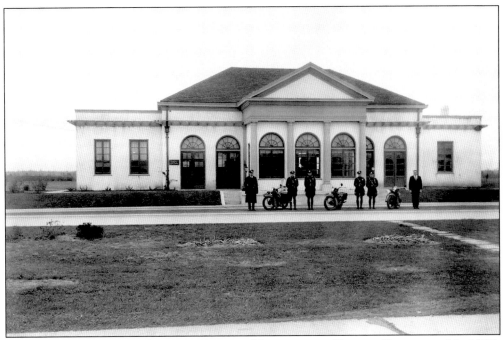

STATE HIGHWAY POLICE STATION NUMBER THREE, NEAR DOVER, DECEMBER 14, 1935. Located at the intersection of Leipsic Road and DuPont Highway one mile north of Dover, the state police station helped served the increasing amount of traffic on the DuPont Highway. (Delaware Public Archives, State Board of Agriculture Photographs, Negative 1730.)

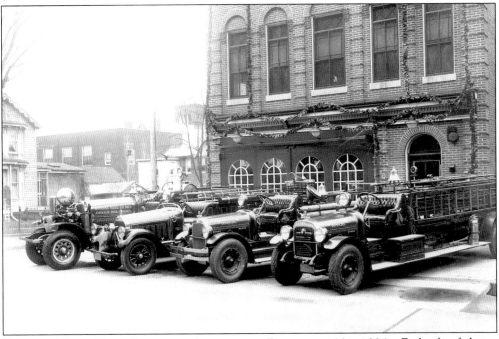

ROBBINS HOSE FIRE COMPANY APPARATUS, DECEMBER 13, 1930. Early fire-fighting equipment used in Dover is proudly presented "in line" for this portrait. (Delaware Public Archives, State Board of Agriculture Photographs, Negative 1200.)

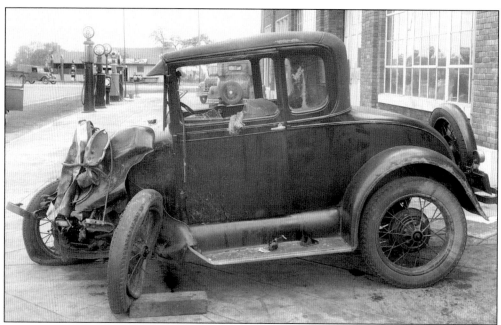

POLICE AUTO AFTER ACCIDENT, NOVEMBER 10, 1932. One of the new dangers facing state police soon became automobile accidents, such as this one involving a state police car. The primary mode of transportation for state police was motorcycle. (Delaware Public Archives, State Board of Agriculture Photographs, Negative 1564.)

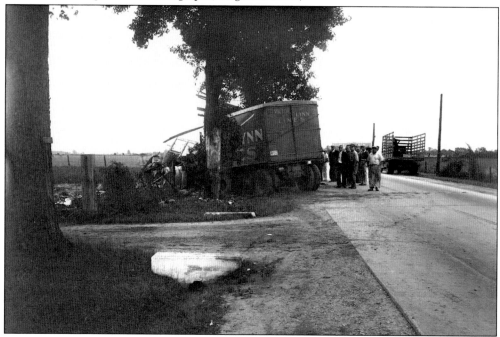

TRUCK ACCIDENT, AUGUST 4, 1933. The growth in automobile traffic in Dover led to a higher rate of accidents, and the results were usually devastating. This Victor Lynn Lines truck was demolished in one such wreck in 1933. (Delaware Public Archives, State Board of Agriculture Photographs, Negative 1600.)

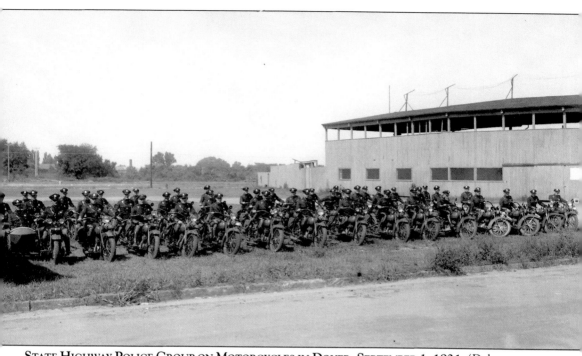

STATE HIGHWAY POLICE GROUP ON MOTORCYCLES IN DOVER, SEPTEMBER 1, 1931. (Delaware Public Archives, State Board of Agriculture Photographs, Negative 1273.)

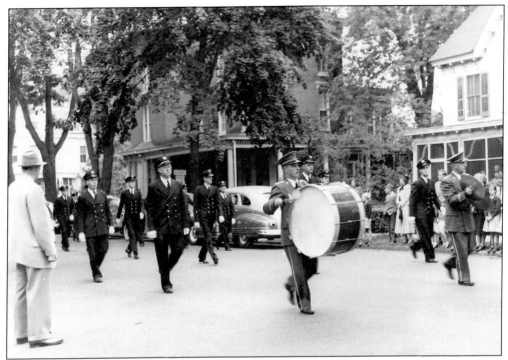

FIREMAN'S PARADE, DOVER, C. 1950. The Robbins Hose Company marches down State Street during the annual parade. (General Collection Local Events, Box 2 #F-9.)

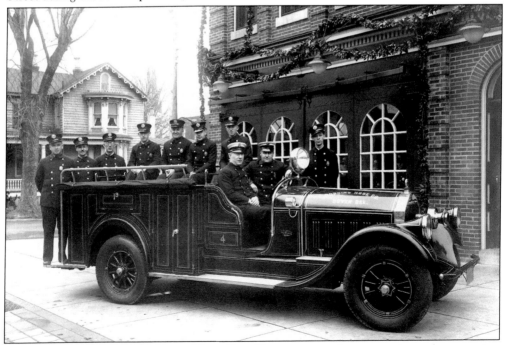

ENGINE 4, 1930. The Robbins Hose Fire Company members are pictured on engine number four, December 13, 1930. (Delaware Public Archives, State Board of Agriculture Photographs, Negative 1203.)

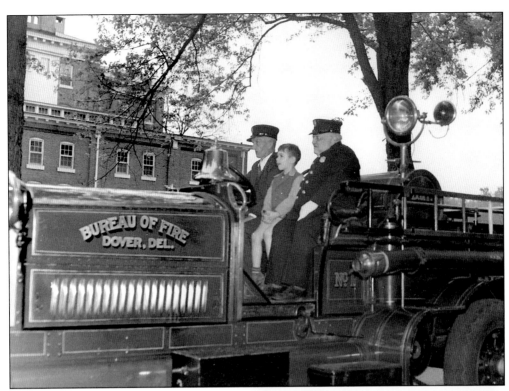

CEREMONIAL ENGINE, 1950. Robbins Hose Fire Company maintains its ties to history by using older apparatus for ceremonies such as parades. Engine number one of the Robbins Hose Fire Company (not shown here) remains a part of the fleet of equipment for the fire company. The engine was purchased by Ed Baker Jr. and restored to its original condition along with his son, Ed Baker III. The engine remains a part of the Robbins Hose roster and is used for ceremonies and parades. (General Collection Local Events, Box 2 Folder 9.)

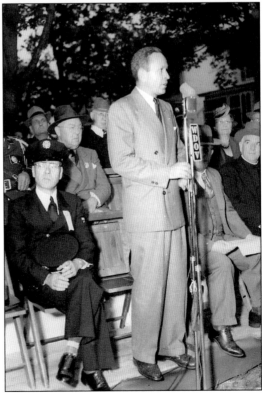

J. CALEB BOGGS'S SPEECH TO THE FIREMEN. Boggs is shown speaking during the annual Fireman's Parade. Boggs enjoyed a lengthy career in Delaware politics, beginning with his 1946 victory in the House of Representatives. He served three terms in the house, as well as two terms as both governor and state senator. Delaware's volunteer firemen remain an important audience for politicians and elected officials. (General Collection Local Events, Box 2 Folder 9.)

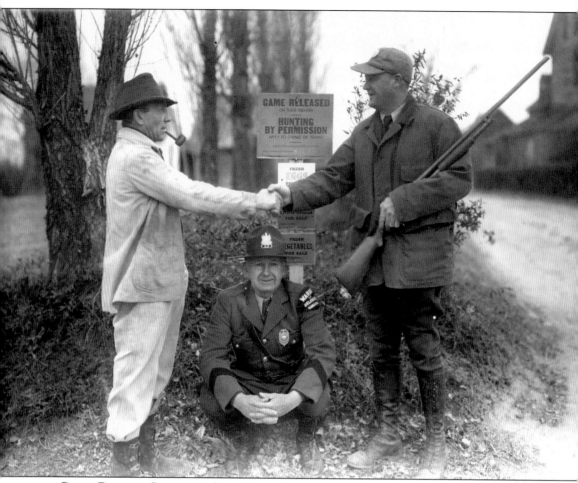

GAME RELEASE SIGN AND SITE, JUST OUTSIDE OF DOVER, N.D. This game release site was opened on February 11, 1938. (Delaware Public Archives, State Board of Agriculture Photographs, Negative 1902.)

Five
FARMS

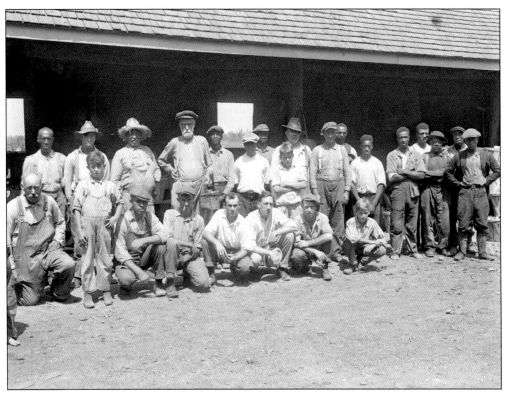

PEACH PICKING CREW AT THE CAPITOL FRUIT FARM IN DOVER, AUGUST 27, 1924. Capitol Fruit Farm was one of the largest orchards in the Dover area and regularly employed both local and itinerant workers as pickers during the harvest season. This group photo of the peach picking crew shows the diversity—in age and race—of these crews. (Delaware Public Archives, State Board of Agriculture Photographs, Negative 215.)

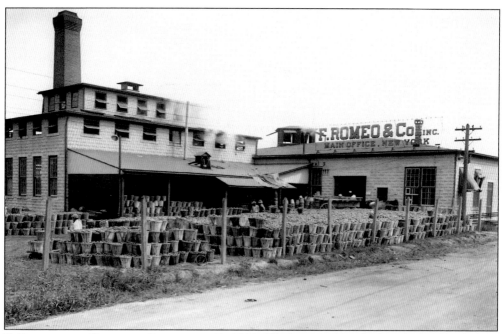

F. ROMEO AND COMPANY, SEPTEMBER 7, 1923. Workers tend to the hundreds of bushels of tomatoes ready for canning outside the F. Romeo and Co. canning plant in Dover. Dover's role as an agricultural hub helped facilitate the rise of the canning industry. Vegetables and fruits picked from Dover's farms could be canned and shipped by train within a few short days. (Delaware Public Archives, State Board of Agriculture Photographs, Negative 82.)

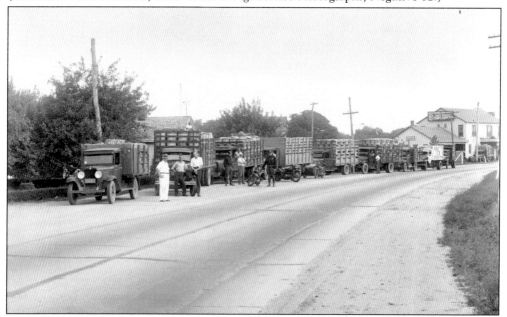

INSPECTION LINE, AUGUST 26, 1931. Trucks lined up at State Police Station for inspection was a regular feature on the roads outside Dover during the late summer and early autumn. Inspections focused on the safety of the trucks and the tonnage they carried. (Delaware Public Archives, State Board of Agriculture Photographs, Negative 1118.)

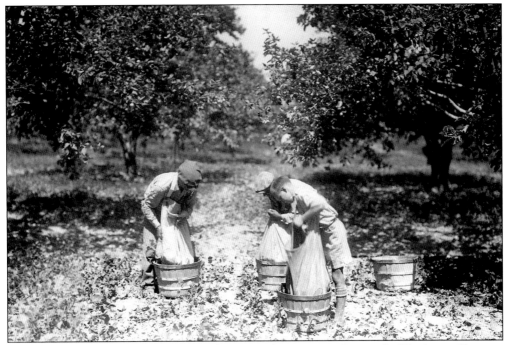
UNLOADING THE APPLE BAG, 1932. These two photos were taken at the Tomlinson Farm on July 13, 1932 to demonstrate the proper technique for loading and unloading apple bags. In this photo, these young pickers demonstrate the proper way—by allowing the bottom of the bag to rest in the crate and opening the bottom flap, thus avoiding bruises to the apples. (Delaware Public Archives, State Board of Agriculture Photographs, Negative 1472.)

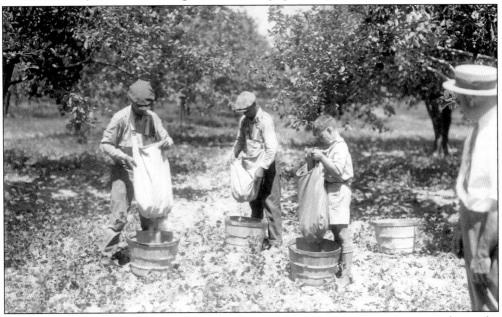
THE WRONG WAY TO UNLOAD AN APPLE BAG, 1932. These same workers now depict the wrong way to unload apple bags, by letting the fruit drop into the basket. (Delaware Public Archives, State Board of Agriculture Photographs, Negative 1473.)

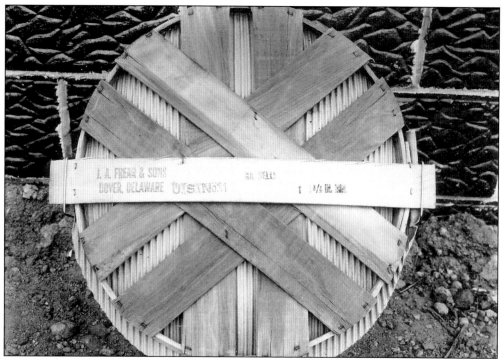

PEACH BASKET FROM FREAR ORCHARDS IN DOVER, AUGUST 12, 1932. The Frear family maintained one of the finest peach farms in all of Dover. The peach crop in Dover was world renown, and farms such as Pfifer's Orchard continue to produce peaches. This peach basket held the "Georgia Belle" variety. (Delaware Public Archives, State Board of Agriculture Photographs, Negative 1488.)

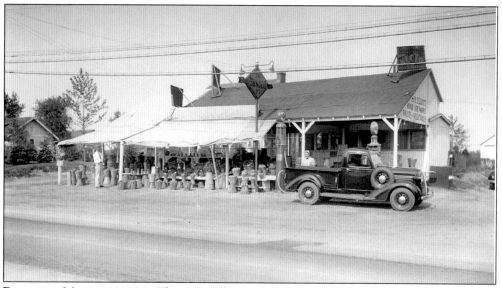

ROADSIDE MARKET, 1936. The S.B. Elliott roadside market on the south side of Dover was one of the first markets to incorporate a gas filling pump at a place traditionally known for the sale of vegetables and fruit. (Delaware Public Archives, State Board of Agriculture Photographs, Negative 1843.)

APPLE PICKING CREW, 1932.
This photograph of the apple picking crew at the W.L. Smith Orchard in Cheswold, just north of Dover, shows the signature narrow-top pickers ladders used to reach the highest fruit. (Delaware Public Archives, State Board of Agriculture Photographs, Negative 1553.)

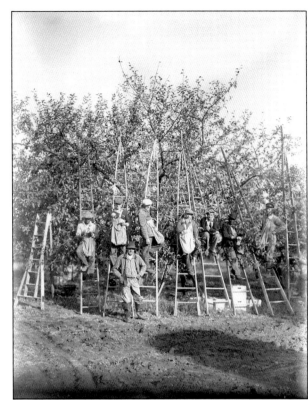

APPLE GRADING, 1932. A second crew at the W.L. Smith Orchards in Cheswold graded and sorted the apples, ensuring that the finest fruits went on for sale as fresh produce, while other apples were used for canning or ciders. (Delaware Public Archives, State Board of Agriculture Photographs, Negative 1552.)

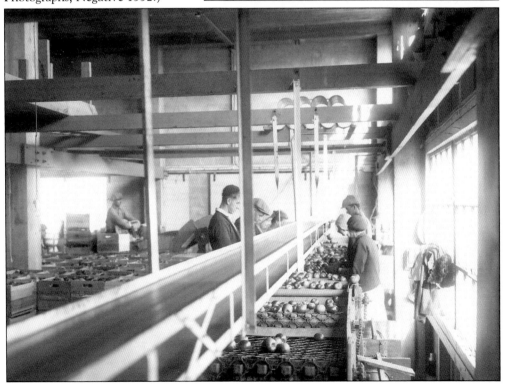

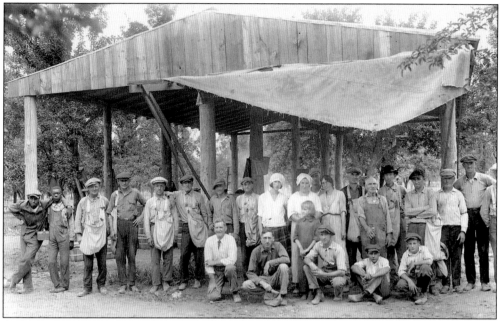

APPLE PICKING CREW AT WALKER MIFFLIN'S FARM IN DOVER, 1923. Many of these pickers were itinerant workers came to Dover annually for the harvest seasons. This crew includes women and children—a suggestion that a portion of the crew may have been an itinerant family. (Delaware Public Archives, State Board of Agriculture Photographs, Negative 56.)

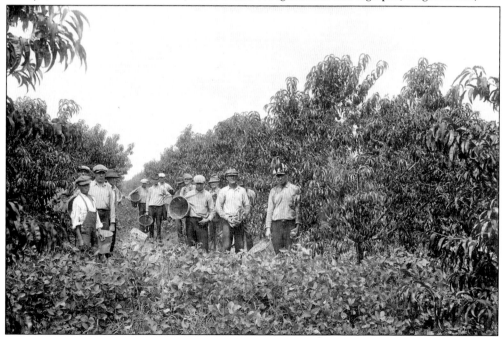

PEACH PICKING CREW AT THE HERBERT RICHARDSON FARM, AUGUST 18, 1925. Peach picking crews typically had the most difficult weather to work in, as the Dover peach crop typically "came in" during the hot and humid months of July and August. (Delaware Public Archives, State Board of Agriculture Photographs, Negative 302.)

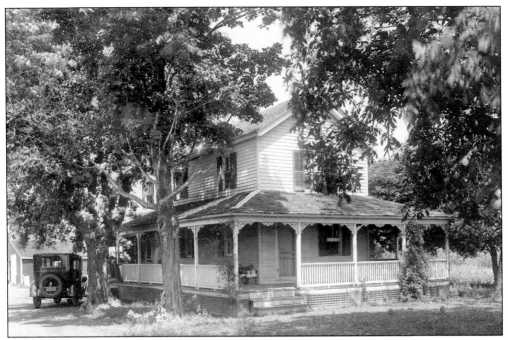

FARM HOUSE AT THE CAPITOL FRUIT FARM IN DOVER, AUGUST 27, 1924. The traditional farm house is a fixture throughout the outlying areas of Dover. (Delaware Public Archives, State Board of Agriculture Photographs, Negative 211.)

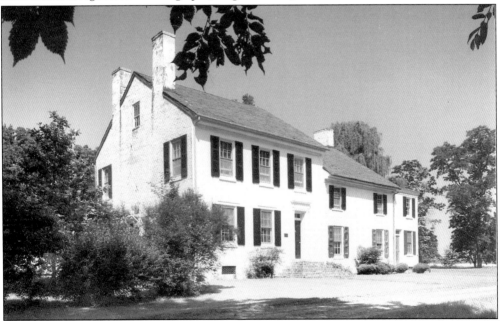

EDEN HILL FARM, N.D. Originally purchased by Nicholas Greenberry Ridgely in 1748, Eden Hill Farm is considered one of Dover's most prized and historic locations. The 262-acre farm has been owned continuously by one family—the Ridgely's, Horsey's, and Schellers—and currently is home to one of the finest nurseries in the state. (Delaware Public Archives, Eberlein Collection, Folder 2.)

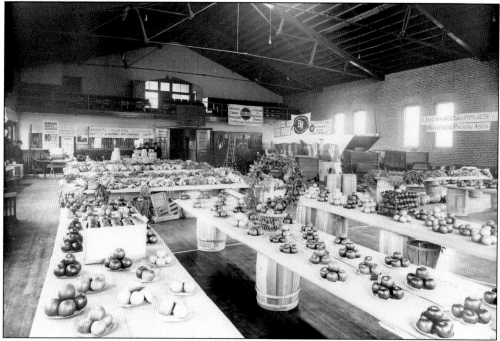

PENINSULA HORTICULTURAL SOCIETY EXHIBIT AT THE DOVER ARMORY, NOVEMBER 22, 1922. Agricultural and horticultural shows were typical in Dover after the harvest was complete. These horticultural show at the Dover Armory included tables from the Bridgeville Packing Association and the Marvel Package Company. (Delaware Public Archives, State Board of Agriculture Photographs, Negative 20.)

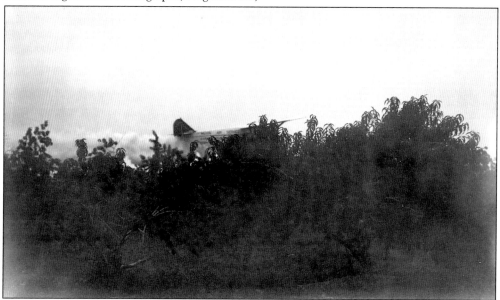

EARLY CROP-DUSTER. Crop-dusting the peach trees by the Wilson Air Service at the W.L. Mifflin Farm in Dover, August 11, 1936. Given the difficulty of action photography in the 1930s, this blurred image represents a one-of-a-kind image of a Delaware farm tradition. (Delaware Public Archives, State Board of Agriculture Photographs, Negative 1858.)

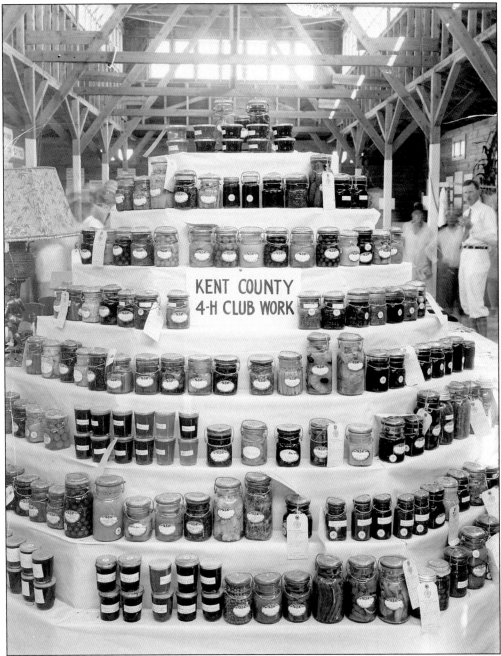

KENT COUNTY 4-H CLUB EXHIBIT, JULY 25, 1928. This is the first exhibit of the Kent County 4-H Club at the State Fair held every year in Harrington, Delaware. The Kent County 4-H Club draws members from across the county, and always includes a large contingent from Dover. (Delaware Public Archives, State Board of Agriculture Photographs, Negative 848.)

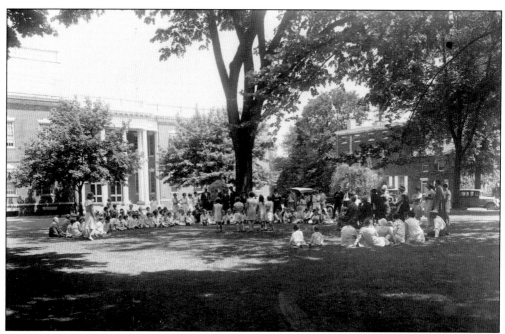

KENT COUNTY 4-H CLUB FIELD DAY ON THE DOVER GREEN, MAY 17, 1930. With the fields planted and the crops in, many farmers and their children often enjoyed the 4-H Field Day held annually in Dover. (Delaware Public Archives, State Board of Agriculture Photographs, Negative 1247.)

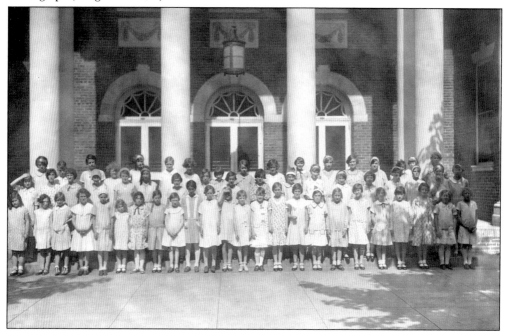

DRESS GROUP OF THE 4-H CLUB AT THE STATE HOUSE, MAY 17, 1930. Dress-making was one of the many activities 4-H promoted, reflective of the difficult times many Delawareans faced during the Great Depression. (Delaware Public Archives, State Board of Agriculture Photographs, Negative 1252.)

Six
SCHOOLS

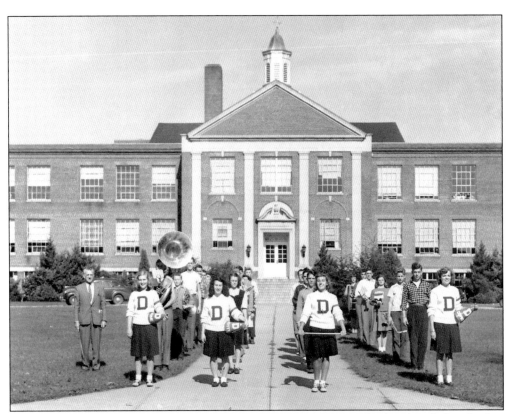

THE DOVER HIGH SCHOOL BAND AND CHEERLEADERS, 1946. The band and cheerleaders practice on the sidewalk in front of what was then Dover High School. The building now houses the Central Middle School. (Delaware Public Archives, General Photograph Collection, Education, Box 1, #2269.)

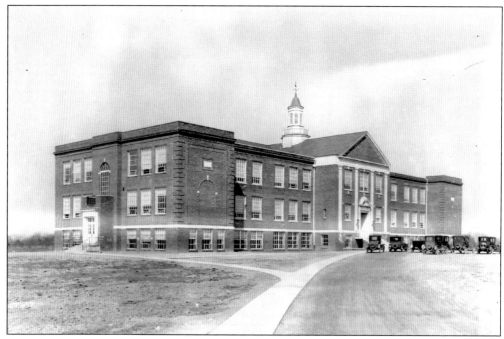

"DOVER SCHOOL BUILDING" ON MARCH 30, 1926. Once serving as Dover High School, this building is now home to the Central Middle School of the Capital School District. (Delaware Public Archives, State Board of Agriculture Photographs, Negative 472.)

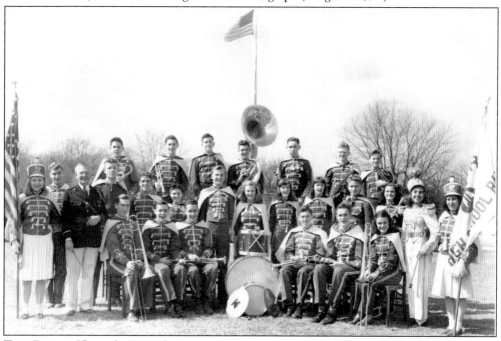

THE DOVER HIGH SCHOOL SENATOR BAND, C. 1945. The Dover High School Senator marching band boasts a long and proud history, as evidenced by this picture of its 26 members in 1945–1946. In 2002, the band and marching units numbered more than 200 members. (Delaware Public Archives, General Photograph Collection, Education, Box 1 #2268.)

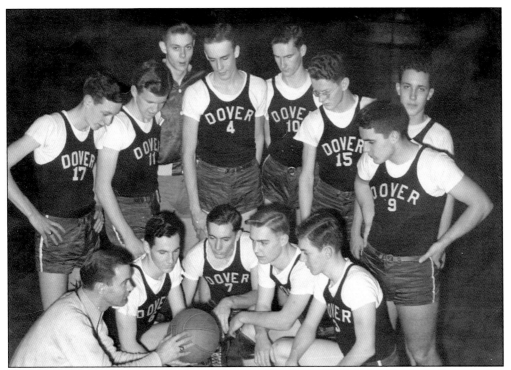

DOVER HIGH SCHOOL BASKETBALL TEAM, N.D. The Dover High School basketball team takes instruction from their coach. (Delaware Public Archives, General Photograph Collection, Education, Box 1, #2273.)

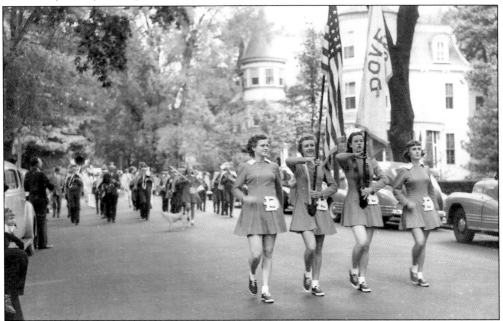

DOVER HIGH SCHOOL CHEERLEADERS, FIREMAN'S PARADE, C. 1950. The cheerleaders are seen marching down State Street during the annual Volunteer Fireman's Parade. (Delaware Public Archives, General Photograph Collection, Local Events, Box 2 Folder 9.)

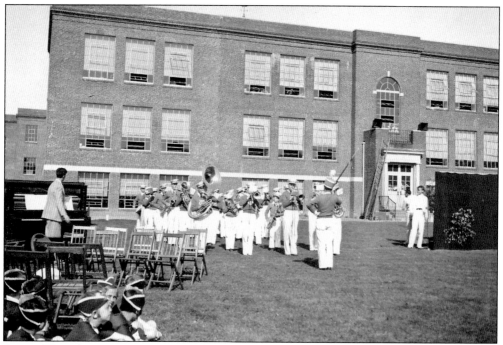

DOVER HIGH SCHOOL BAND, MAY 1933. The Dover High School band performs during a May concert on the lawn of the school. (Delaware Public Archives, General Photograph Collection, Education, Box 1 Folder 9.)

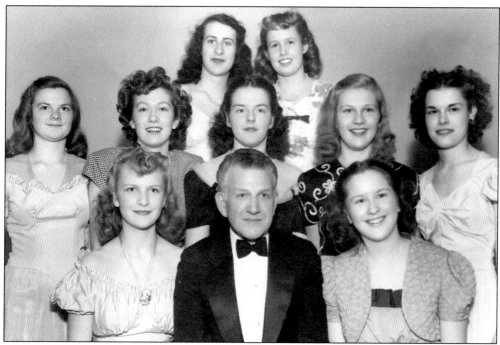

DOVER HIGH GIRLS OCTET, 1945–1946. Dover High School's rich tradition of music programs included a series of spring concerts, including the Girls Octet. (Delaware Public Archives, General Photograph Collection, Education, Box 1 Folder 9.)

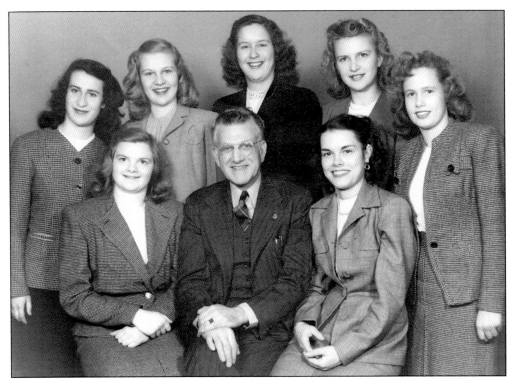

Dover High School Girls Choir, 1945–1946. The Dover High Girls Choir is now a regular fixture at community events and competitions. (Delaware Public Archives, General Photograph Collection, Education, Box 1 Folder 9.)

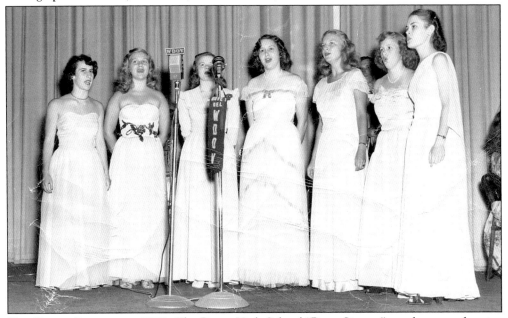

The Betty Singers, c. 1950. The Dover High School "Betty Singers" are shown performing for a radio broadcast on WDOV. (Delaware Public Archives, General Photograph Collection, Education, Box 1, #2272.)

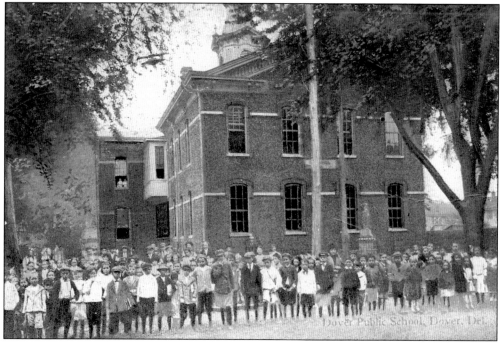

DOVER PUBLIC SCHOOL, C. 1900. The Dover Public School was located at the corner of Queen and Division Streets. (Delaware Public Archives, Post Card Collection #611137.)

BOOKER T. WASHINGTON SCHOOL, 1926. Shown just before being populated with students, the Booker T. Washington School was originally built as a "colored school" for Dover. Delaware Public Archives, State Board of Agriculture Photographs, Negative 435.)

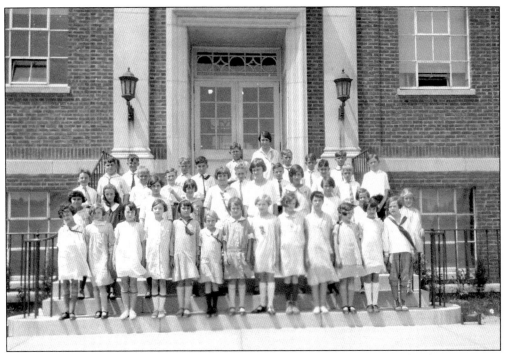

FOURTH GRADE, 1926. Fourth graders in the Dover School District pose for this picture on June 1, 1926. (Delaware Public Archives, Board of Education: Dover, Box 1 Folder 7.)

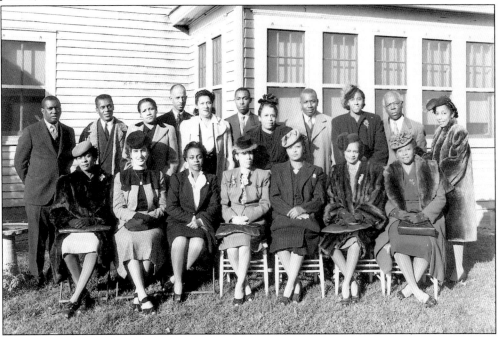

AFRICAN-AMERICAN TEACHERS, C. 1940S. This photo included a hand-written notation— "William Henry faculty"—and is thought to be a photograph of some of the first African-American teachers in Dover. (Delaware Public Archives, Purnell Photograph Collection, Box 3 Folder 10.)

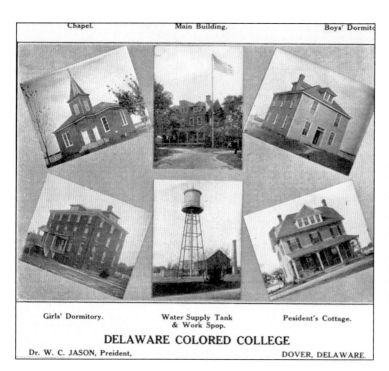

ADVERTISEMENT FOR DELAWARE COLORED COLLEGE, N.D. This early advertisement for the Delaware Colored College highlights some of the early buildings on the campus. The College would later be renamed Delaware State College and is now known as Delaware State University. (Delaware Public Archives, General Photograph Collection Education, Kent County, Box 1 Folder 1.)

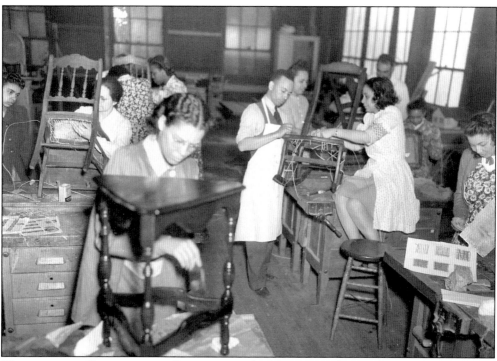

WORKSHOP IN CANNING AND REFINISHING AT DELAWARE STATE COLLEGE, N.D. While starting as a primarily agricultural and technical school, Delaware State University is today a research and teaching university offering graduate-level programs. (Delaware Public Archives, Purnell Photograph Collection Box 3 Folder 10.)

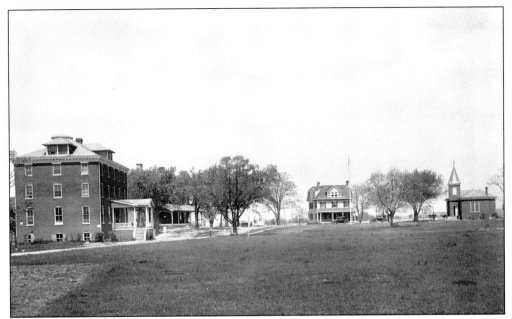

EARLY PHOTOGRAPH OF DELAWARE STATE COLLEGE, MAY 6, 1926. The development of the Delaware State University campus has been tremendous over the past 30 years. (Delaware Public Archives, State Board of Agriculture Photographs, Negative 519.)

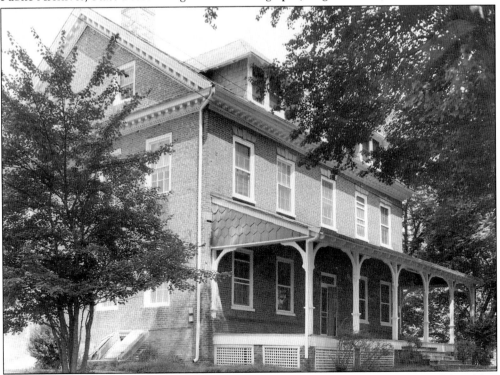

LOOCKERMAN HALL, DELAWARE STATE COLLEGE, N.D. Loockerman Hall is one of the oldest structures on the original campus. (Delaware Public Archives, General Photograph Collection, Education, Kent County, Box 1 Folder 1.)

CONRAD HALL, N.D. Conrad Hall, on the campus of Delaware State University, housed the Home Economics department. (Delaware Public Archives, General Photograph Collection Education, Kent County, Box 1 Folder 1.)

NEW BUILDING, COLORED COLLEGE, 1928. The school is now Delaware State University, and is known as one of the state's finest academic institutions. (Delaware Public Archives, State Board of Agriculture Photographs, Negative 946.)

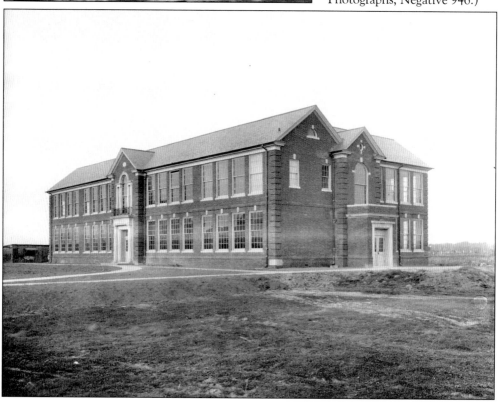

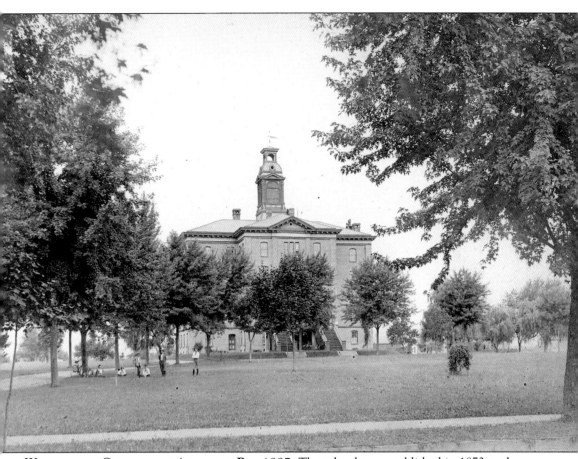

WILMINGTON CONFERENCE ACADEMY, PRE-1897. The school was established in 1873 as the Wilmington Conference Academy. A suspicious fire destroyed the main building in 1876, and it was later rebuilt. The school's name was changed to Wesley Collegiate Institute in 1918, and began offering a two-year college curriculum. Wesley College conferred its first four-year degrees in 1978 and added graduate programs in the 1990s. (Delaware Public Archives, Janson Collection, Folder 4.)

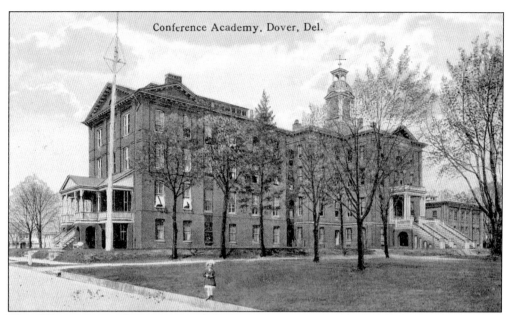

THE WILMINGTON CONFERENCE ACADEMY, C. 1921. Wesley College's main building remains the hub of student and academic life on the campus. (Delaware Public Archives, Post Card Collection #6626721.)

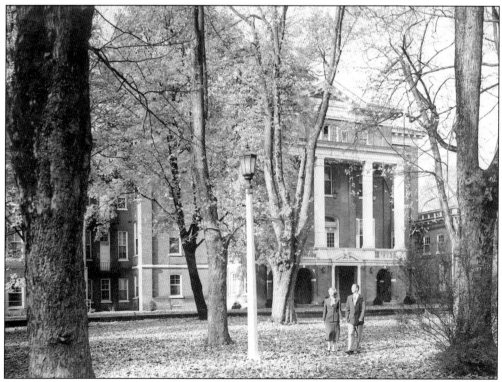

WESLEY JUNIOR COLLEGE, STATE STREET, DOVER, C. 1950S. Two students enjoy a beautiful fall day on the campus in the early 1950s. (Delaware Public Archives, General Photograph Collection Schools, Box 1 Folder 8.)

Seven
Business and Industry

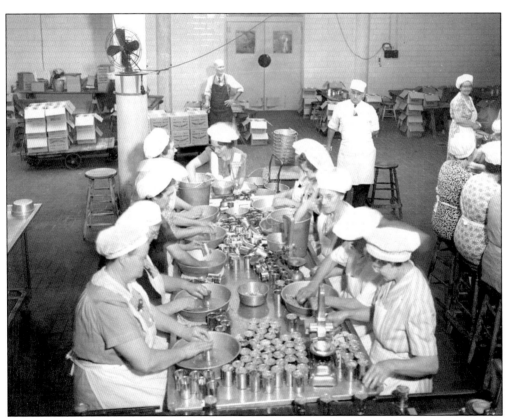

RICHARDSON AND ROBBINS PLANT CANNERY, C. 1947. The Richardson and Robbins Plant on Kings Highway was once one of the premier canning facilities in Delaware. Here a supervisor watches over the assembly line during production. Mrs. John E. Abbott is shown weighing cans in the lower right-hand corner. (Delaware Public Archives, General Photograph Collection, Business & Industry, Box 1 Folder 6.)

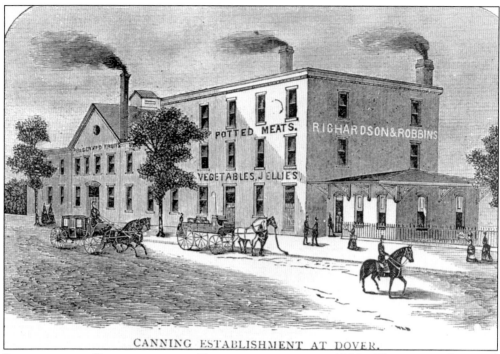

SKETCH OF THE RICHARDSON AND ROBBINS PLANT IN THE 1880S. The company's canned foods first hit the market in 1855, after several years of experimentation. Richardson and Robbins were instrumental in the development of the canning industry in the US. (Delaware Public Archives, General Photograph Collection, Business & Industry, Box 1 Folder 6.)

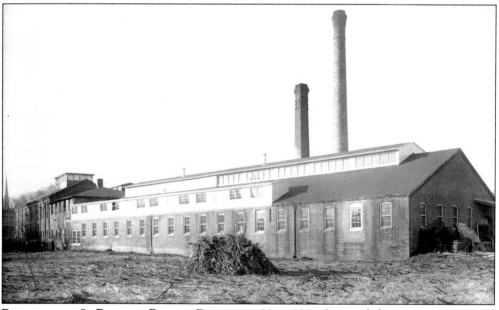

RICHARDSON & ROBBINS PLANT, DECEMBER 22, 1928. Some of the company's canned products included fruits, meats, and vegetables. In 1975, the company went out of business after operating for 125 years. (Delaware Public Archives, State Board of Agriculture Photographs, Negative 961.)

DELAWARE STATE NEWS, N.D. Pictured here is the home of the *Delaware State News*, a daily newspaper continuing to serve the Dover community. (Delaware Public Archives, General Photograph Collection, Business and Industry, Box 1 Folder 6.)

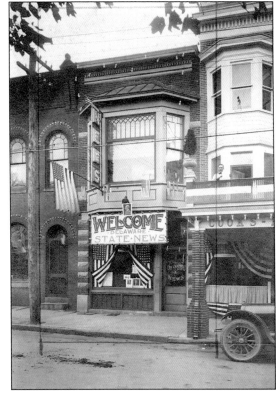

DELMARVA ICE CREAM PLANT, 1928. This photograph shows the huge production facility for this widely popular ice cream. According to the sign, the company slogan reads "Its pure that's sure." (Delaware Public Archives, State Board of Agriculture Photographs, Negative 962.)

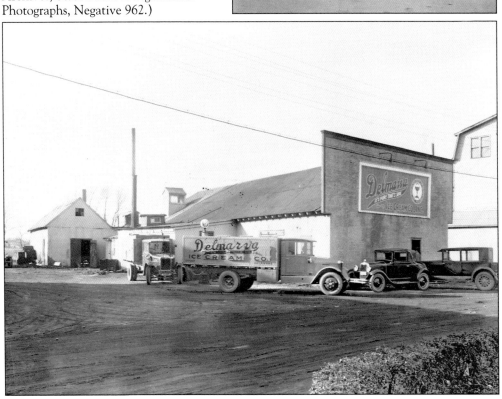

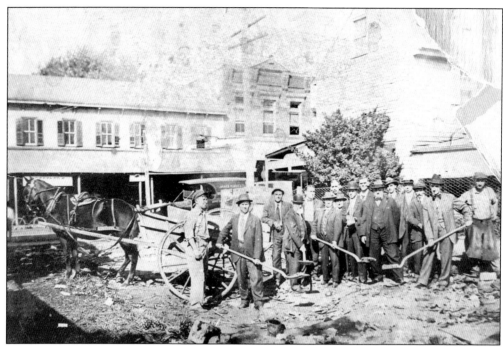

GROUNDBREAKING FOR THE TEMPLE THEATER, 1920. The theater held hundreds of cultural events until its demise. The town blacksmith, Mr. Peterson is at the far right. (Delaware Public Archives, General Photograph Collection, Business and Industry, Box 1, Folder 8.)

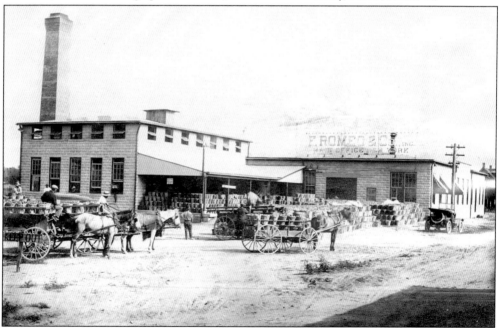

F.C. ROMEO AND CO. CANNERY, C. 1920. Serving the fruit orchards located outside Dover and throughout Kent County, Romeo's was one of the largest canneries serving central Delaware. (Delaware Public Archives, General Photograph Collection, Business and Industry, Box 1 Folder 6, Web Dover 21.)

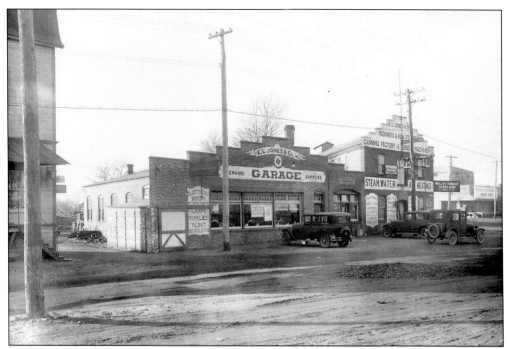

E.L. JONES & CO. PLANT, DECEMBER 22, 1928. E.L Jones promised "electrical wiring, fixtures, lamps, supplies, and installation." The company also included plumbing supplies and service to Dover. (Delaware Public Archives, State Board of Agriculture Photographs, Negative 956.)

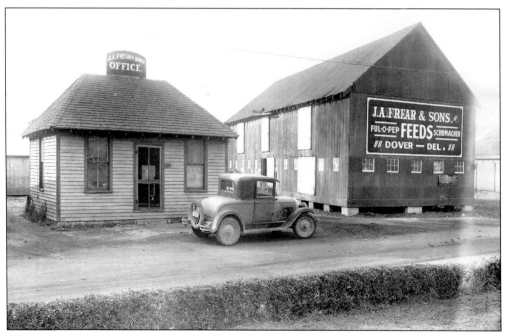

J.A. FREAR & SONS OFFICE, NOVEMBER 17, 1928. The company was a major supplier to farmers in the area and, as witnessed by its billboard advertising, sold the "Ful-O-Pep" line of feed. (Delaware Public Archives, State Board of Agriculture Photographs, Negative 949.)

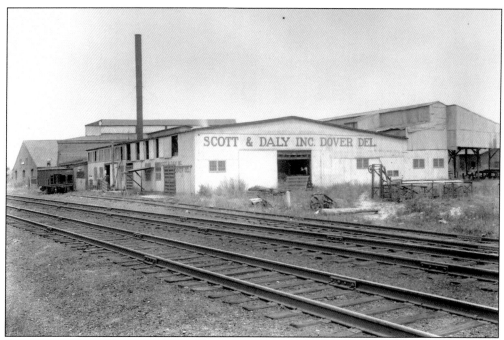

SCOTT AND DALY CANNING FACTORY, 1929. This photo shows one of the many canneries existing at that time in the Dover area. The close proximity of the railroad tracks allowed for quick pick up and delivery of goods. (Delaware Public Archives, State Board of Agriculture Photographs, Negative 1020.)

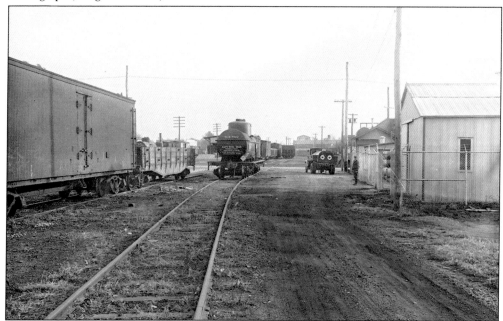

RAILROAD FREIGHT YARD IN DOVER, NOVEMBER 17, 1928. Railroad tracks on the west side of Dover continue to serve the Delmarva Peninsula and are an important route for commerce for the eastern shore. (Delaware Public Archives, State Board of Agriculture Photographs, Negative 945.)

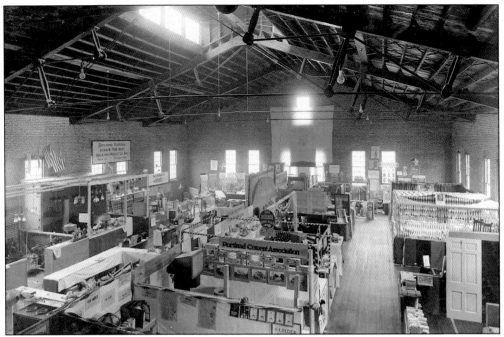

"BETTER HOMES" EXHIBITION AT THE DOVER ARMORY, FEBRUARY 29, 1924. Home shows such as this were a common venue for local artisans to promote their wares, and often included booths for new home models, indoor appliances, and other home improvements. (Delaware Public Archives, State Board of Agriculture Photographs, Negative 133.)

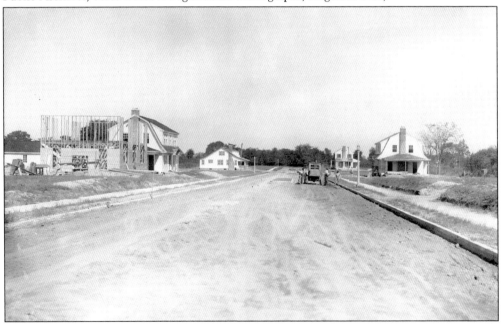

RODNEY ROAD, SEPTEMBER 22, 1928. Now considered one of the nicer streets in "Old Dover." This early shot of Rodney Road shows just four completed homes, all of which are still residences today. Rodney Road ends at Silver Lake Park. (Delaware Public Archives, State Board of Agriculture Photographs, Negative 922.)

BECKETT HOUSE, HIGHLAND PARK DEVELOPMENT, DOVER, SEPTEMBER 22, 1928. A building boom in the late 1920s saw new "developments" such as Highland Park initiated. (Delaware Public Archives, State Board of Agriculture Photographs, Negative 921.)

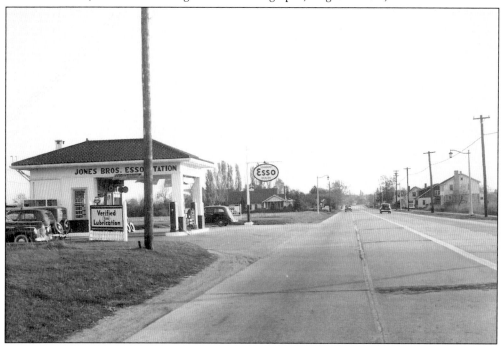

JONES BROTHERS ESSO STATION, N.D. Located on North State Street and looking north toward Silver Lake, the former filling station remains standing today. (State Highway Department collection, Box 6 Folder 6.)

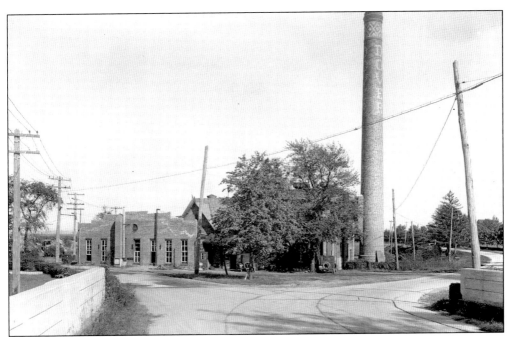

TOWN WATER & ELECTRIC PLANT, OCTOBER 6, 1928. The City of Dover maintains its own electric utility plant, one of the few municipalities of its size to do so. (Delaware Public Archives, State Board of Agriculture Photographs, Negative 932.)

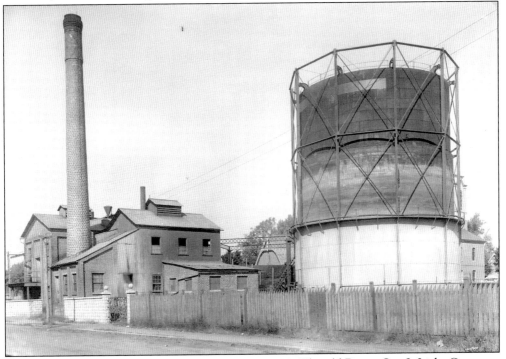

DOVER GAS & LIGHT CO. PLANT, OCTOBER 6, 1928. The old Dover Gas & Light Company was demolished. The city is now served by modern facilities operated by Chesapeake Utilities. (Delaware Public Archives, State Board of Agriculture Photographs, Negative 931.)

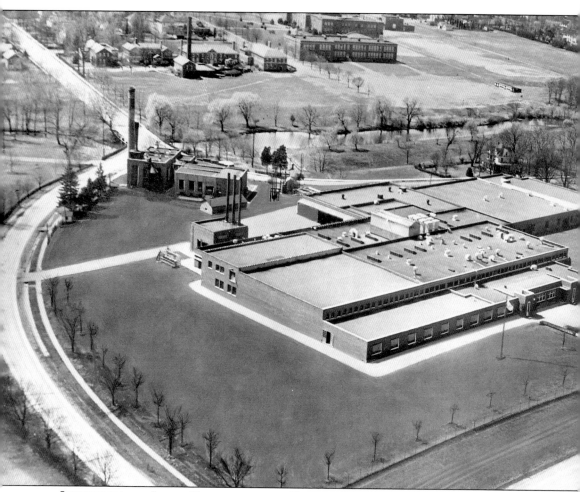

INTERNATIONAL LATEX CORPORATION AT PLAYTEX PARK, DOVER. The company's founder, Abram N. Spanel, moved the headquarters to Dover in 1937. The facility at Division Street and Kings Highway led the way for further industrial growth in the Dover area. (Delaware Public Archives, Purnell Photograph Collection, Box 3 Folder 1.)

Eight
AROUND TOWN

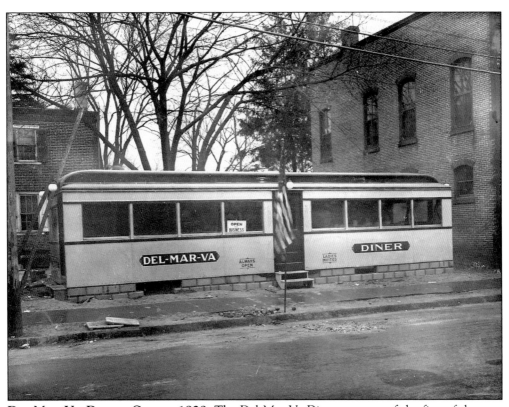

DEL-MAR-VA DINING CAR, C. 1929. The Del-Mar-Va Diner was one of the first of the new "diner" businesses designed to attract motorists traveling through Dover. The signs on the front say "always open" and "ladies invited." (Delaware Public Archives, State Board of Agriculture Photographs, Negative 968.)

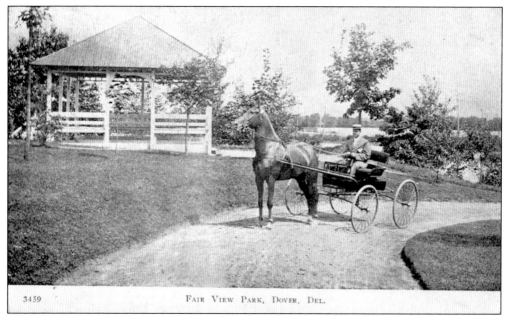

FAIR VIEW PARK, 1908. Located in what was then the city's undeveloped northwest end, Fair View Park served the recreation needs of the community. This section of town is now a development called Fairview and includes Fairview Elementary School. (Delaware Public Archives, Post Card Collection, #5947.)

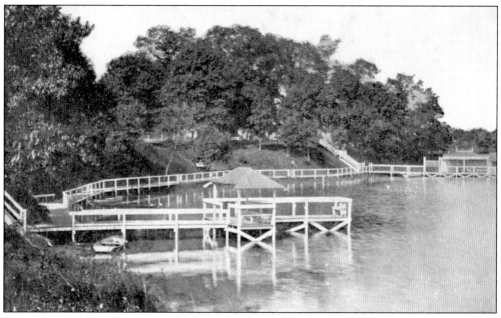

SILVER LAKE PARK, 1904. Silver Lake Park is located on the north end of the downtown area and has served as a major recreational area for Dover. The lake once boasted piers and docks, and residents used paddleboats on the lake. Pollution woes hurt this venue in the 1970s, but a concerted effort to clean the lake's water and waterfront has resulted in the restoration of Dover's most significant natural feature. (Delaware Public Archives, Post Card Collection, #52252.)

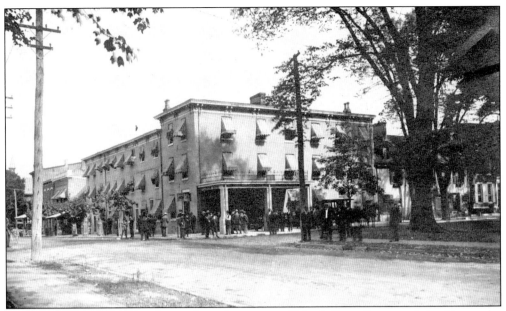

CAPITOL HOTEL, C. 1920. Situated on the corner of North State Street and the Green, the Capitol Hotel replaced the famous Golden Fleece Tavern. It was on this site (in the Golden Fleece Tavern) that the Delaware General Assembly ratified the U.S. Constitution in 1787, thus making Delaware the "First State." (Delaware Public Archives, General Photograph Collection, Business and Industry, Box 1 Folder 5.)

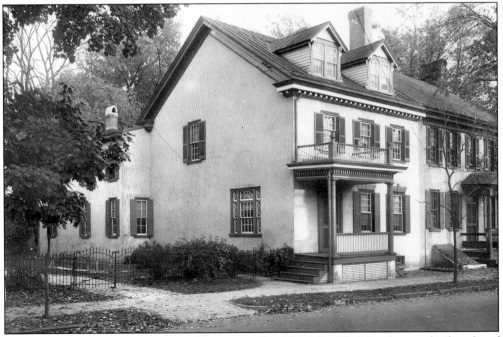

RESIDENCE OF MISS ELLA MURPHY, NOVEMBER 5, 1922. Miss Ella Murphy was the founder of the Murphy School for children in Dover. Her residence is on South Street just north of Water Street; the structure remains today and is home to a law office. (Delaware Public Archives, State Board of Agriculture Photographs, Negative 853.)

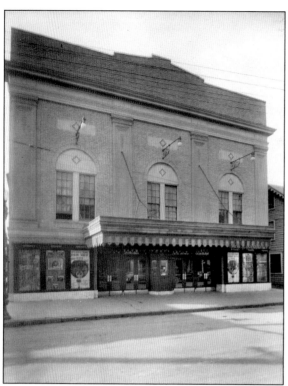

THE DOVER OPERA HOUSE, DECEMBER 9, 1929. Later renamed the Capitol Theater, this venue served the entertainment needs of Dover until it closed in the 1980s. The theater was refurbished and re-opened in 2000 as the Schwartz Center for the Arts and now serves as the flagship cultural attraction in downtown Dover. (Delaware Public Archives, State Board of Agriculture Photographs, Negative 1080.)

MCKINNEY'S ESSO, APRIL 27, 1958. McKinney's Esso station on the corner of South Governor's Avenue and Bank Lane was one of the last gas service stations to serve the downtown area. The site is currently occupied by Holmes Insurance Agency. (Delaware Public Archives, Purnell Photograph Collection, Box 3 Folder 1.)

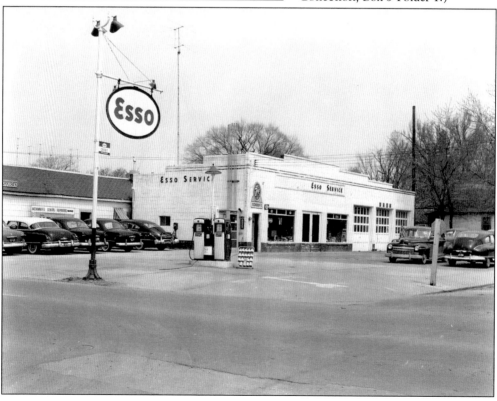

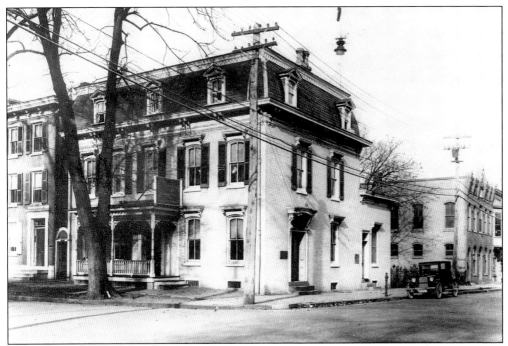

WALTER L. FOX POST NO. 2 AMERICAN LEGION BUILDING IN DOVER, NOVEMBER 26, 1923. This building sits on the northwest corner of State Street and the Green. The American Legion Post was chartered in 1919. (Delaware Public Archives, State Board of Agriculture Photographs, Negative 121.)

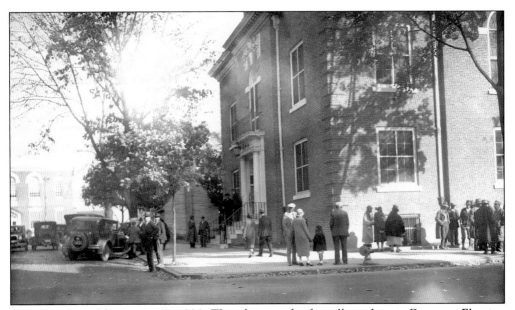

ELECTION DAY, NOVEMBER 6, 1928. This photograph of a polling place in Dover on Election Day included information that it was the "2nd district." Upon closer inspection of the photograph, all of the people standing on the right hand side of the photograph are African Americans. (Delaware Public Archives, State Board of Agriculture Photographs, Negative 942.)

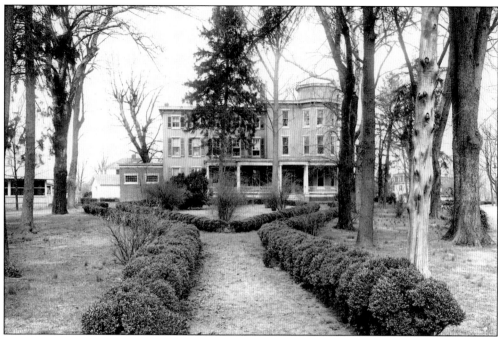

HANDY RESIDENCE, MARCH 1932. The Handy family residence was a prominent home in Dover, replete with a boxwood hedge in the shape of a diamond. (Delaware Public Archives, State Board of Agriculture Photographs, Negative 1409.)

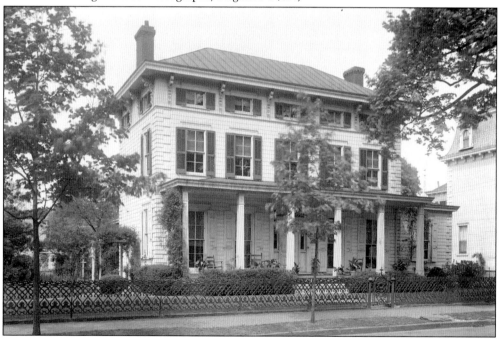

HOME OF J.W. BENSON, MAY 8, 1928. This magnificent home on South State Street remains one of the prime attractions in Dover's Historic District. In the 1990s, the home was restored and donated to Wesley College and now serves as the President's Home. (Delaware Public Archives, State Board of Agriculture Photographs, Negative 904.)

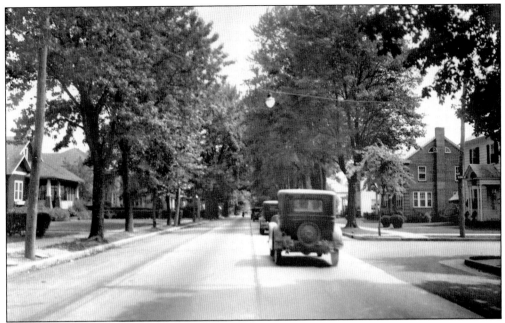

STATE STREET, 1929. State Street remains Dover's most glorious entrance, welcoming traffic from Route 13 at Silver Lake and traversing the historic district. This photograph of State Street at Clara Street looks much the same today—a tree-lined road with well-kept homes. (Delaware Public Archives, State Board of Agriculture Photographs, Negative 1036.)

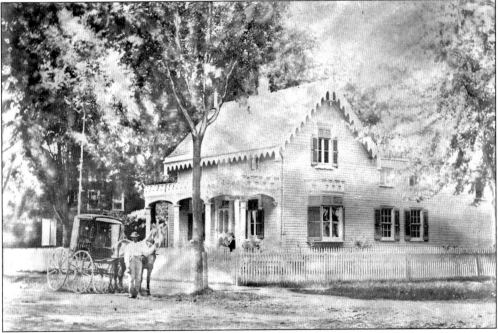

ROSE COTTAGE, N.D. Rose Cottage sits at the corner of Reed Street and State Street, just across from the People's Church. The Cottage is on the National Register of Historic Places and currently serves as the administrative home to the Delaware State Museums. (Delaware Public Archives, State Board of Agriculture Photographs, Negative 1906.)

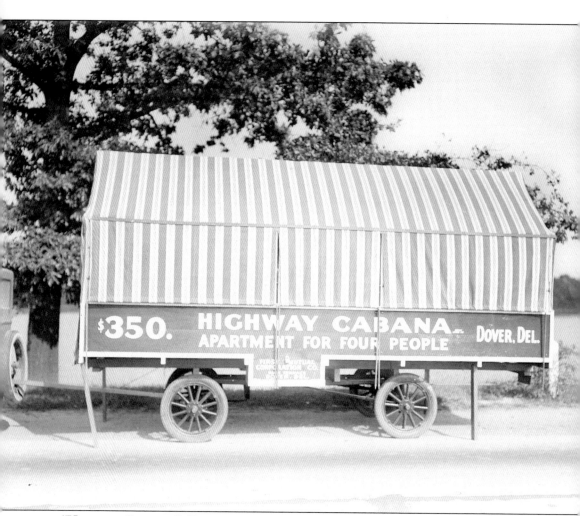

"HIGHWAY CABANA." TRAILER OF RIDGELY HARRINGTON, SEPTEMBER 12, 1931. This trailer is an early version of an overnight camper and was pulled by a motor vehicle and used for sleeping up to four people. (Delaware Public Archives, State Board of Agriculture Photographs, Negative 1285.)

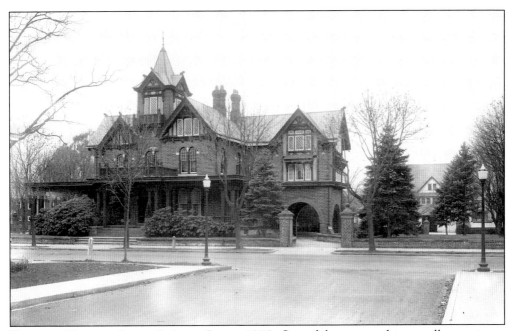

HISTORIC HOME OF JAMES F. ALLEE JR., C. 1928. One of the most architecturally prominent homes in Dover, the Allee Home is colloquially referred to as "The Castle." The home sits at the corner of State Street and Mary Street; this photograph is taken from Hazel Road. (Delaware Public Archives, State Board of Agriculture Photographs, Negative 955.)

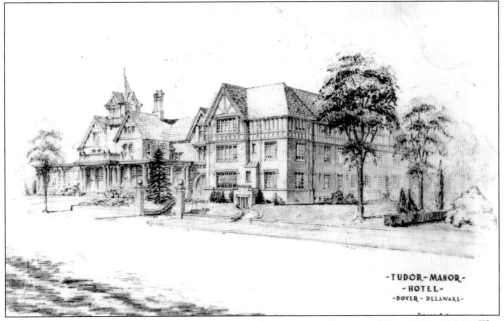

ARCHITECTS RENDERING OF A PROPOSED HOTEL FOR DOVER, MAY 24, 1929. The proposed "Tudor Manor Hotel" would have added a significant addition to the home of James Allee on North State Street. The addition was never built. The architect rendering was done be Brown & Whiteside. (Delaware Public Archives, State Board of Agriculture Photographs, Negative 995.)

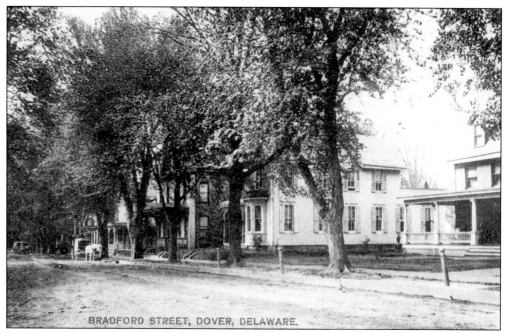

BRADFORD STREET, N.D. Bradford Street remains one of the most vibrant residential streets in the downtown area, and connects Loockerman Street with Wesley College. (Delaware Public Archives, General Photograph Collection, Cities and Towns, Box 1 Folder 3.)

FOREST STREET, 1939. Forrest Street is in the city's West End and borders the railroad tracks which serve Dover. This street and others in the West End are the focus of current improvement projects in Dover. (Delaware Public Archives, General Photograph Collection, Cities and Towns, Box 1 Folder 3.)

HOSPITAL FUND-RAISING CLOCK, 1925. The "Indicator clock" used during the hospital drive for funds in Dover in 1925 show the overall goal of raising $100,000 for the construction of the new hospital. Today, Bayhealth Medical Center provides medical services to the entire region. (Delaware Public Archives, State Board of Agriculture Photographs, Negative 249.)

NEW HOSPITAL, 1926. Kent General Hospital on State Street is seen under construction on May 6, 1926. Portions of the façade of this building are still visible inside the newly reconstructed Bayhealth Medical Center. (Delaware Public Archives, State Board of Agriculture Photographs, Negative 521.)

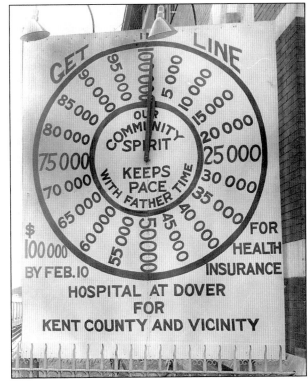

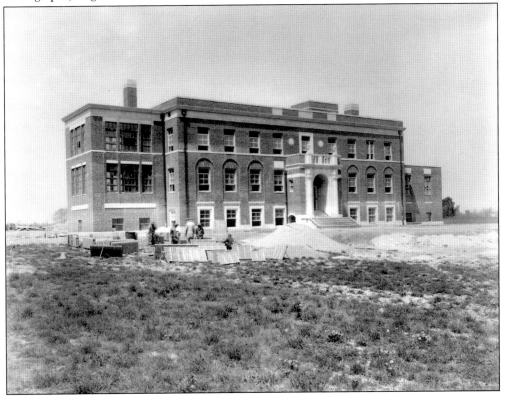

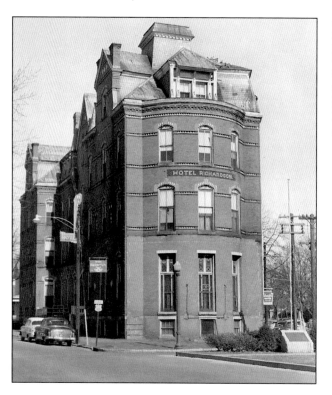

FINAL DAYS OF THE HOTEL RICHARDSON, 1954. The Hotel Richardson on February 18, just days before the wrecking ball razed the structure. (Delaware Public Archives, General Photograph Collection, Business and Industry, Box 1 Folder 7.)

DEMOLITION OF THE HOTEL RICHARDSON, 1954. The destruction of the Hotel Richardson left a vacant triangle-shaped parcel in the downtown area; the Wilmington Trust Company now has a bank on this site. (Delaware Public Archives, General Photograph Collection, Business and Industry.)

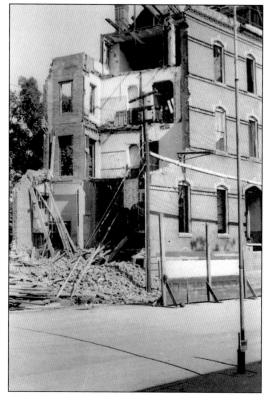

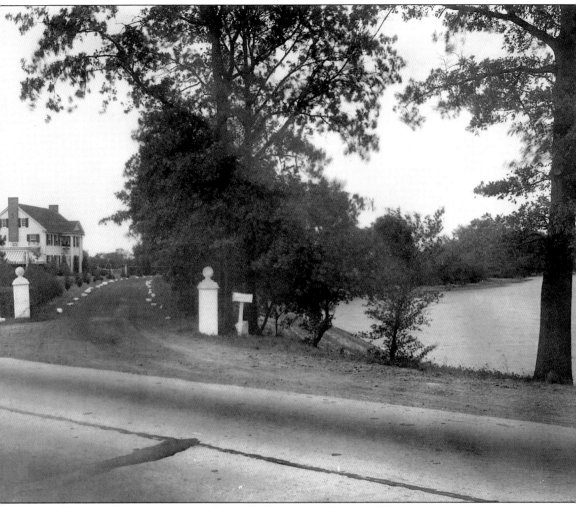

SILVER LAKE AT SIPPLES, AUGUST 8, 1929. On the north side of Silver Lake sits the former Sipple Residence. The residence was later home to the Schwartz family, owners and operators of the Capitol Theater in Dover. Mrs. Muriel Schwartz, who was instrumental in having the theater turned into the Schwartz Center for the Arts, continues to live in the residence. (Delaware Public Archives, State Board of Agriculture Photographs, Negative 1030.)

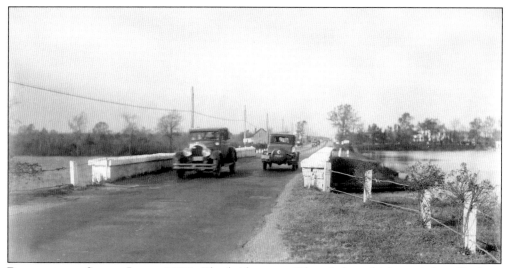

BRIDGE OVER SILVER LAKE, 1933. The bridge over Silver Lake, which carried traffic from Governor's Avenue and State Street (and now, Walker Road) over the lake was once no more than a single-lane bridge. Prior to the opening of the DuPont Highway, this served as a major artery for vehicular traffic going south. As automobile traffic around the area grew in Dover, the bridge became more and more dangerous and was widened. (Delaware Public Archives, State Board of Agriculture Photographs, Negative 1620.)

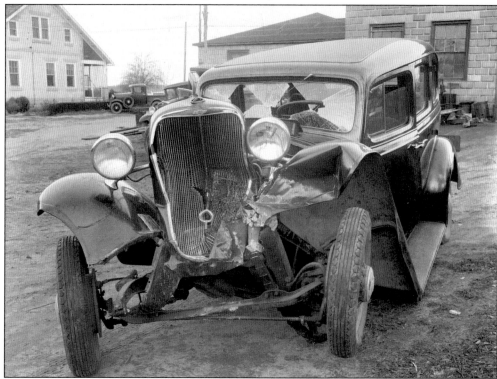

CHEVROLET BELONGING TO MR. COATESVILLE INVOLVED IN ACCIDENT ON SILVER LAKE BRIDGE, NOVEMBER 8, 1933. (Delaware Public Archives, State Board of Agriculture Photographs, Negative 1621.)

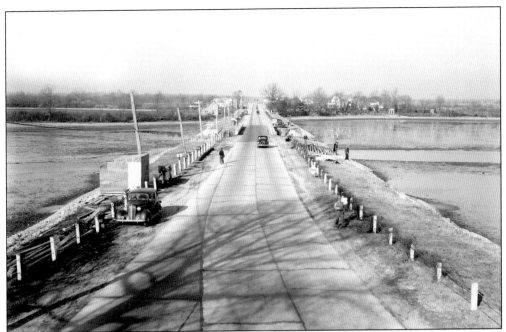

NEW CAUSEWAY OVER SILVER LAKE, DECEMBER 14, 1936. Workers place the finishing touches on the new causeway which takes traffic from State Street and Governor's Avenue over Silver Lake. The causeway is still in use today, with the famed Blue Coat Inn sitting on the northeast side of the structure. (Delaware Public Archives, State Highway Department, Box 6 Folder 6.)

INTERSECTION OF STATE STREET AND GOVERNOR'S AVENUE. This intersection was once one of the busiest in all of Dover, with drivers deciding on taking State Street and heading through town toward the beaches, or taking Governor's Avenue and heading south down the Delmarva peninsula. The street sign at the intersection gives distances to both Rehoboth Beach and Salisbury, Maryland. (Delaware Public Archives, Purnell Photograph Collection, Box 3 Folder 12.)

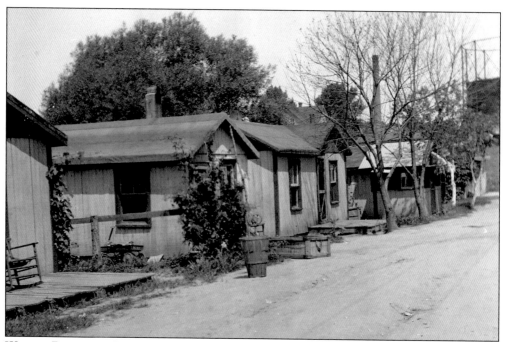

WILLEM PROPERTY, BANK LANE TO NEW STREET, C. 1934. These workingmen's homes on Bank Lane were just a few short steps from the grandeur and historical architecture of the Green. (Delaware Public Archives, General Photograph Collection, Houses, Box 4 Folder 1.)

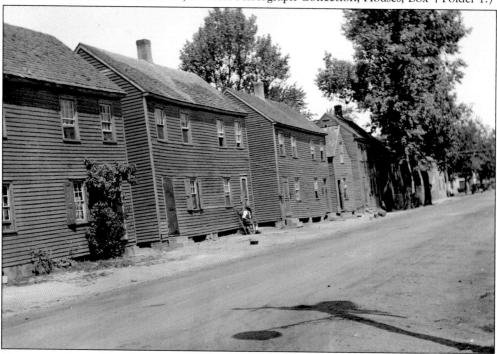

HOUSES ON SHOT GUN ALLEY IN DOVER, JUNE 26, 1934. This is a rare photograph of Dover's slums. Boarding houses and apartment houses such as these were often used by factory and farm workers. (Delaware Public Archives, General Photograph Collection, Houses, Box 4 Folder 1.)

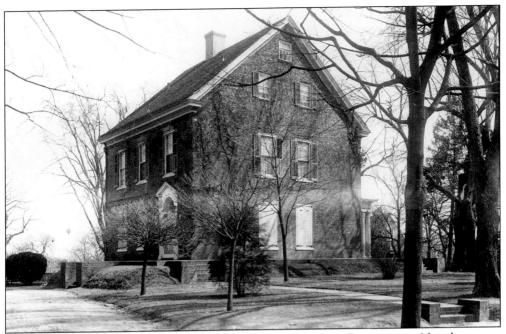

AN EARLY SHOT OF "COWGILL HOUSE" ON KING STREET IN DOVER, N.D. Now known as Woodburn, this currently serves as the Governor's official residence in Dover. (Delaware Public Archives, State Board of Agriculture Photographs, Negative 471.)

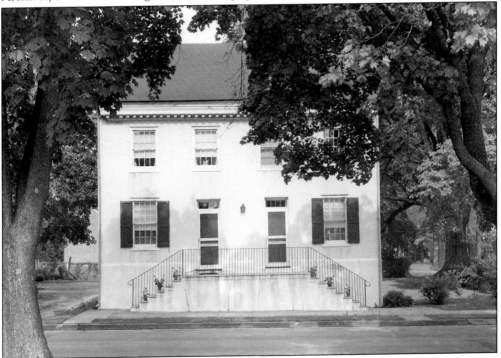

BANNING HOUSE, N.D. The Banning House, located on South State Street and Elm Terrace, served as home to an academy in the early 1800s. The house was built in 1766 and remains today. (Delaware Public Archives, General Photograph Collection Houses, Box 1 Folder 4.)

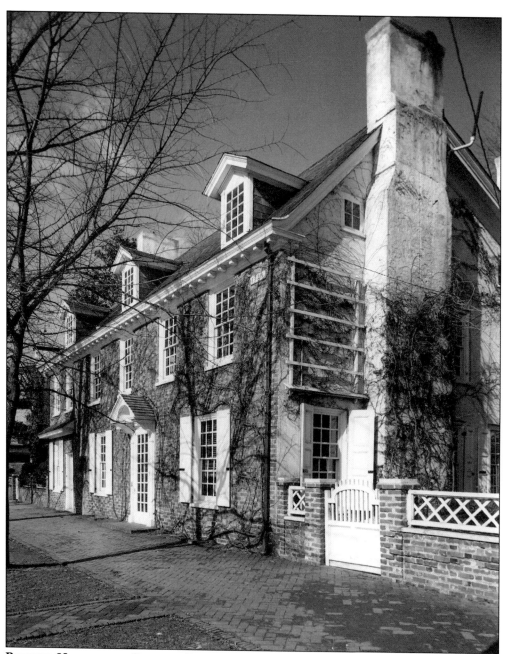

RIDGELY HOUSE AND GARDEN, BUILT IN 1728. The house was built in 1728 by famed architect Thomas Parke and was the home of two prominent Dover residents, Henry and Mabel Lloyd Ridgely. Mr. Ridgely was a lawyer and also served as chairman of the board of the Farmer's Bank of Delaware. Mrs. Ridgely was a founding member and president of the Delaware Public Archives Commission. She also served as president of the Women's Suffrage Committee, and was known as the founder of Old Dover Days. (Delaware Public Archives, Eberlein Collection, Folder 2.)

Nine
CHURCHES

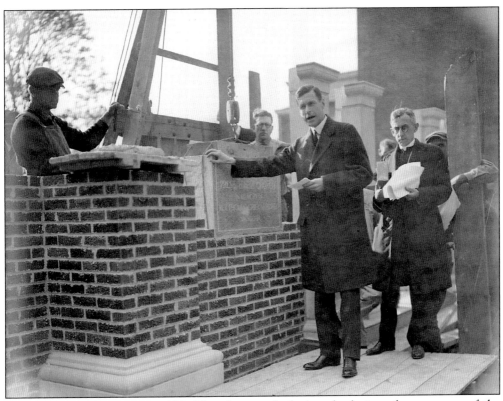

CORNERSTONE CEREMONY, 1923. The photograph depicts the laying of cornerstone of the Dover Presbyterian Church, May 1, 1923. Cornerstone reads "Dover Presbyterian Church, In memory of Rev. Thomas Grier Murphy, MCMXXIII." (Delaware Public Archives, State Board of Agriculture Photographs, Negative 36.)

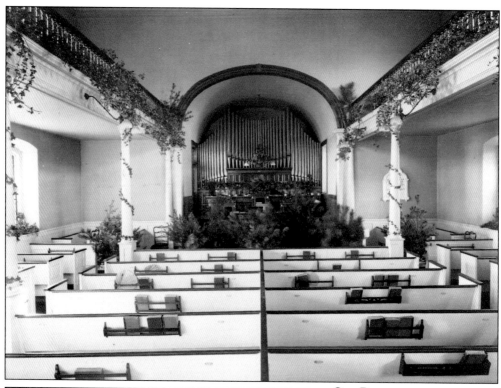

OLD PRESBYTERIAN CHURCH OF DOVER, AS DECORATED FOR CHRISTMAS, DECEMBER 24, 1923. An early photograph shows the interior of the new church. (Delaware Public Archives, State Board of Agriculture Photographs, Negative 125.)

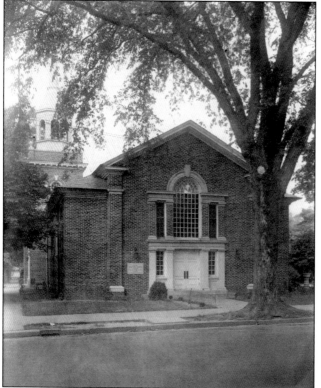

PRESBYTERIAN CHURCH IN DOVER, AUGUST 9, 1929. The Presbyterian Church continues to be one of the most prominent congregations in Dover. (Delaware Public Archives, State Board of Agriculture Photographs, Negative 1971.)

WESLEY M.E. CHURCH IN DOVER, MARCH 15, 1926. Wesley United Methodist Church was organized on September 13, 1778 with the congregation meeting at various locations until the construction of this church in 1851. (Delaware Public Archives, State Board of Agriculture Photographs, Negative 541.)

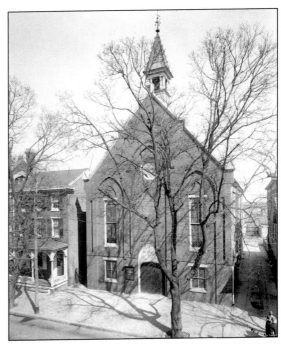

PEOPLE'S CHURCH IN DOVER, AUGUST 13, 1930. The People's United Church of Christ was established in 1909 and the temporary meeting place of the new congregation was the Dover Opera House. A building committee raised the funds for this structure, and the church was dedicated in October 1924. (Delaware Public Archives, State Board of Agriculture Photographs, Negative 1969.)

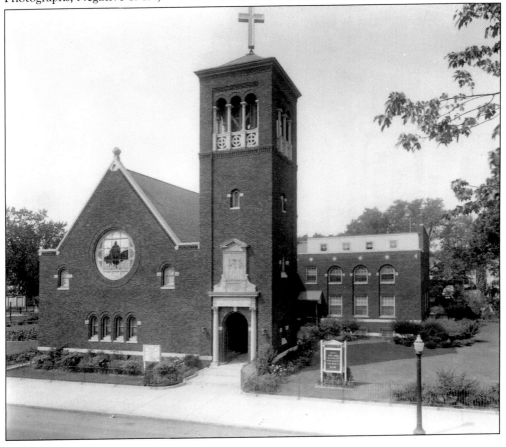

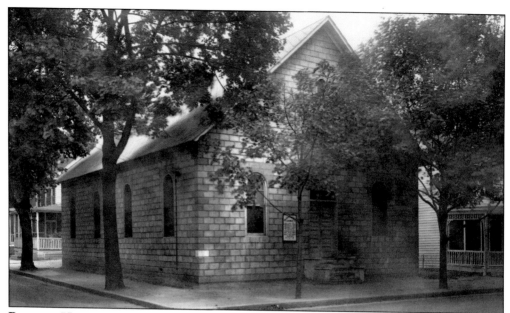

PILGRIMS HOLINESS CHURCH, AUGUST 8, 1929. The Pilgrim Holiness Church was originally organized in 1914. The congregation built this church at the corner of New and Reed Streets in 1924. (Delaware Public Archives, State Board of Agriculture Photographs, Negative 1028.)

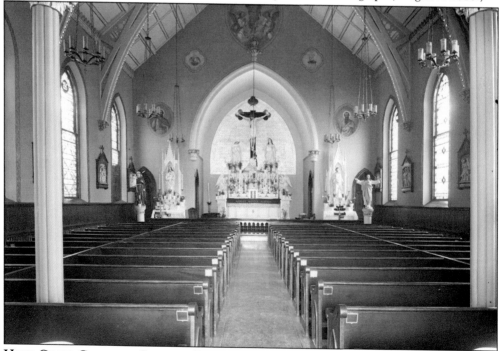

HOLY CROSS CATHOLIC CHURCH, INTERIOR, 1928. Catholic masses were being offered in Dover as early as 1751 by priests serving the eastern shore. This church site was originally purchased in 1871. The church would later move to land purchased on the south side of Dover, across from Kent General Hospital. (Delaware Public Archives, State Board of Agriculture Photographs, Negative 617.)

ST. PAUL'S M.E. CHURCH, AUGUST 8, 1929. St. Paul's Methodist Church has its origination in the 1880s, when some Methodists began holding meeting in the old Armory building under the name of "Armory M.E. Chapel." The church eventually bought a site and built a church on Division Street in the 1890 and was formally renamed St. Paul's M.E. Church in 1922. (Delaware Public Archives, State Board of Agriculture Photographs, Negative 1029.)

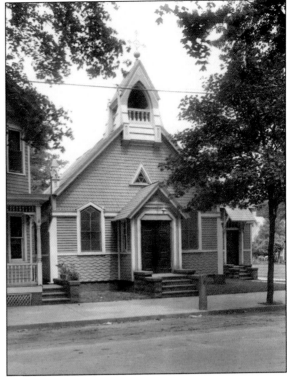

WESLEY M.E. CHURCH INTERIOR, MARCH 17, 1931. The quaint interior of Wesley M.E. Church includes a floor which slopes toward the altar. (Delaware Public Archives, State Board of Agriculture Photographs, Negative 1172.)

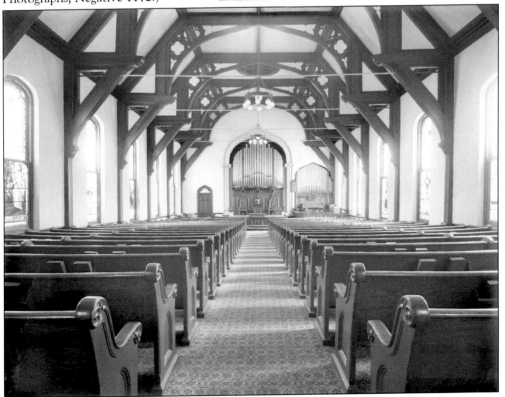

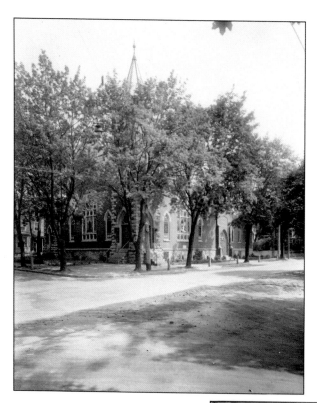

BAPTIST CHURCH, AUGUST 13, 1929. Visible through the trees is the First Baptist Church of Dover. In the 1980s, the church sold this property and built a new church on Walker Road. This structure is now owned by Wesley College. (Delaware Public Archives, State Board of Agriculture Photographs, Negative 1045.)

CHRIST P.E. CHURCH IN DOVER, OCTOBER 13, 1926. Considered one of the most historic sites in Dover, Christ Church was originally a log church built on a tract of land donated by Col. Robert French in 1704. The church was located in "Church Square," as was designated by the layout of Dover designed by William Penn. Prior to 1767, the church was also known as "St. Jones Church." (Delaware Public Archives, State Board of Agriculture Photographs, Negative 536.)

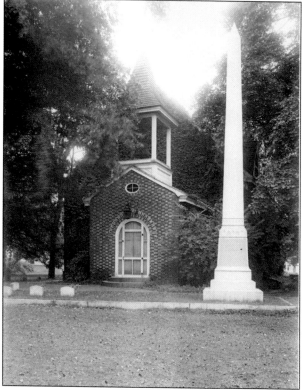

Ten
A CAPITAL CITY

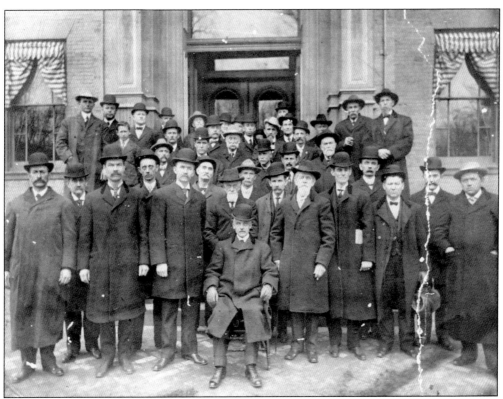

THE DELAWARE GENERAL ASSEMBLY, N.D. In this early, undated (and unidentified) picture, members of the Delaware General Assembly gather for a group portrait. Dover has served as home to the General Assembly since its inception in 1704, bringing together elected officials from all three counties in the state. (Delaware Public Archives, Purnell Photograph Collection, Box 3 Folder 2.)

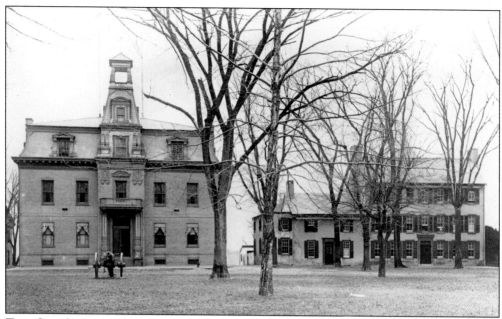

THE OLD STATE HOUSE, N.D. Located on The Green in downtown Dover, the building features an impressive display of early Georgian Colonial architecture. It served as the home of the Delaware Legislature prior to the construction of Legislative Hall. The building is currently a historical site operated by Delaware State Museums. (Delaware Public Archives, General Photograph Collection, Cities and Towns, Box 1 Folder 5.)

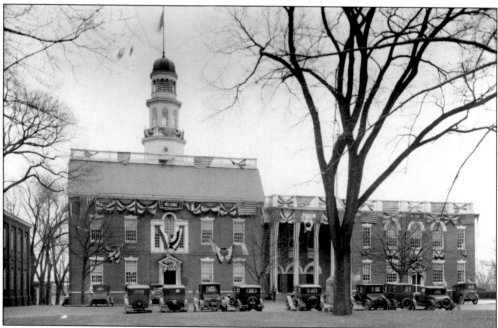

OLD STATE HOUSE ON INAUGURATION DAY, 1929. The State House is decorated in impressive fashion for the inauguration of Gov. C. Douglass Buck. Buck would serve two terms as governor and was later elected to the United States Senate. (Delaware Public Archives, State Board of Agriculture Photographs, Negative 967.)

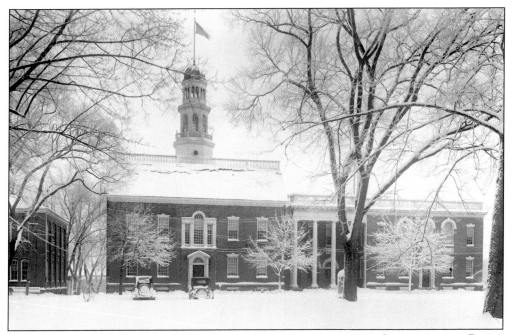

OLD STATE HOUSE AFTER SNOW STORM, FEBRUARY 10, 1926. Snowstorms in Dover, although not rare, did provide a unique opportunity for photographers. (Delaware Public Archives, State Board of Agriculture Photographs, Negative 408.)

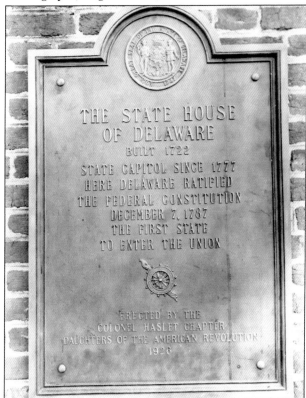

DAR MEMORIAL, N.D. Tablet placed at Old State House by Daughters of the American Revolution, February 23, 1926. (Delaware Public Archives, State Board of Agriculture Photographs, Negative 420.)

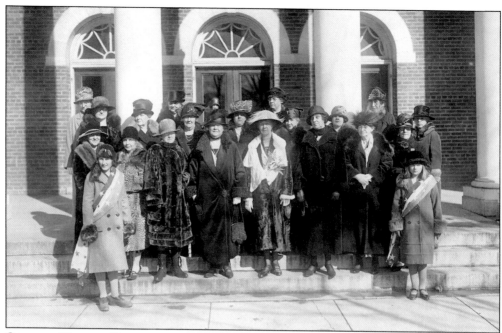

COLONEL HASLET CHAPTER OF THE DAUGHTERS OF THE AMERICAN REVOLUTION WITH PRESIDENT GENERAL MRS. ANTHONY W. COOK, FEBRUARY 23, 1926. The Colonel Haslet Chapter of the DAR remains an active chapter and has been instrumental in the preservation of the state's archives. (Delaware Public Archives, State Board of Agriculture Photographs, Negative 411.)

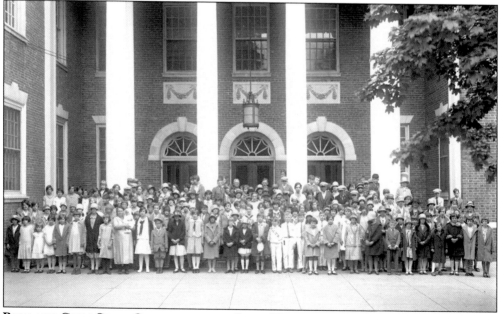

BOYS AND GIRLS CLUBS GATHERED AT THE STATE HOUSE ON JUNE 21, 1927. One of the first gatherings of its kind for various boys and girls clubs across the state drew hundreds of children to the State House for a portrait. (Delaware Public Archives, State Board of Agriculture Photographs, Negative 571.)

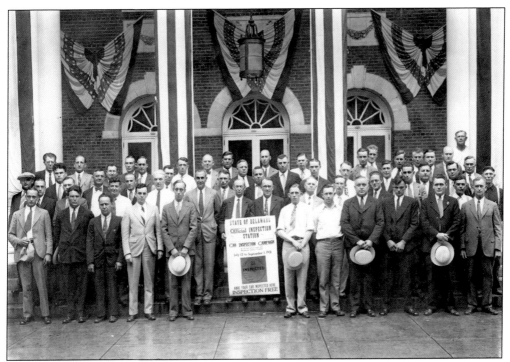

CAR INSPECTION CAMPAIGN, N.D. Members of the Delaware Safety Council pose at the State House as part of a campaign to initiate car inspections. The growing number of automobiles and trucks in Delaware resulted in the first inspection stations to be opened in July 1931. (Delaware Public Archives, State Board of Agriculture Photographs, Negative 1165.)

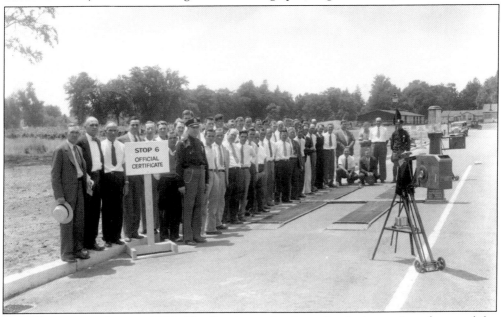

FIRST INSPECTION LANES, 1931. The first inspection lanes for the inspection of automobiles opened in Dover in 1931. (Delaware Public Archives, State Board of Agriculture Photographs, Negative 1949.)

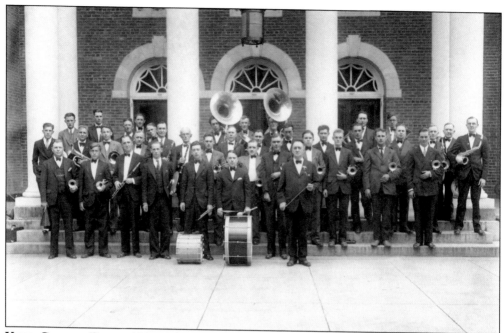

KENT COUNTY BAND, 1931. The Kent County Band was composed of adult musicians from across the county and was a fixture at many special events. Here members of the band pose at the State House on May 10, 1931. (Delaware Public Archives, State Board of Agriculture Photographs, Negative 1183.)

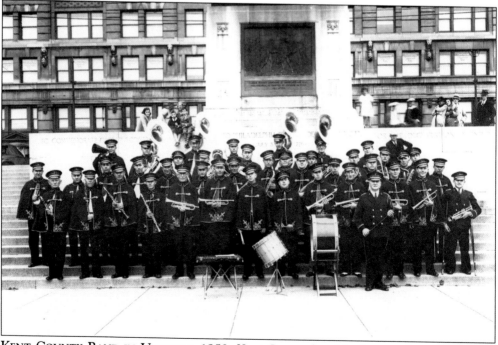

KENT COUNTY BAND IN UNIFORM, 1952. Kent County band in dress uniforms in front of the Caesar Rodney Memorial in Wilmington, after performing at Rodney Square, October 23. (Delaware Public Archives, State Board of Agriculture Photographs, Negative #1538.)

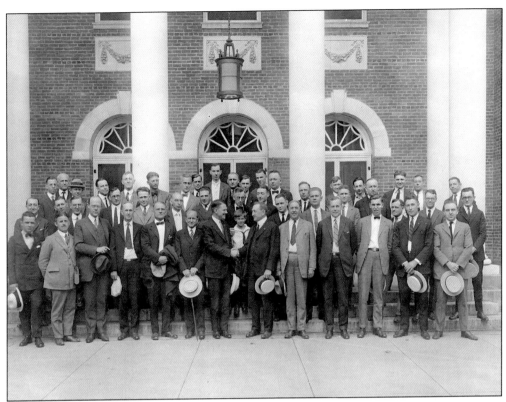

AMERICAN LEGION, 1923. Commander Owsley of the American Legion gathers with Legion members on the steps of the State House to initiate the 1923 American Legion fund-raiser. (Delaware Public Archives, State Board of Agriculture Photographs, Negative 52.)

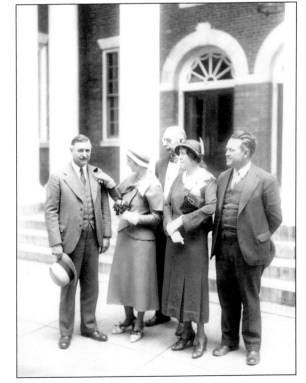

POPPY SALES, 1932. Major Woodford purchasing the first poppy on the steps of the State House, May 14. (Delaware Public Archives, State Board of Agriculture Photographs, Negative 1456.)

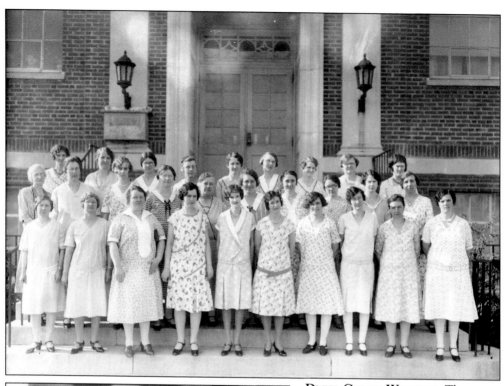

DRESS GROUP WINNERS. The 4-H Adult Dress Group on the steps of the Old State House, April 26, 1930. (Delaware Public Archives, State Board of Agriculture Photographs, Negative 1095.)

4-H GROUP ON THE STATE HOUSE STEPS, MARCH 12, 1932. 4-H leaders have maintained a long and proud history of providing guidance to children and service to the community. (Delaware Public Archives, State Board of Agriculture Photographs, Negative 1431.)

STYLE SHOW. 4-H DRESS GROUP STYLE SHOW PARTICIPANTS, MAY 18, 1929. The dress show participants show off their wares at the old State House. (Delaware Public Archives, State Board of Agriculture Photographs, Negative 991.)

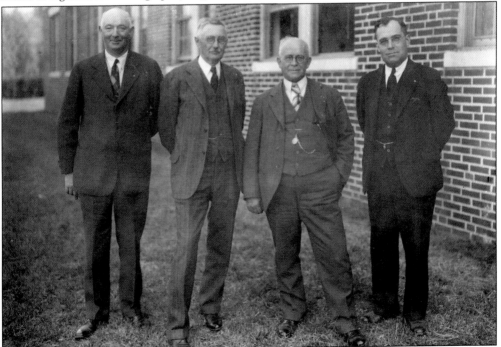

MASTER FARMERS WITH R.W. HEIM, MAY 2, 1930. These Master Farmers were considered to be among the most accomplished farmers in Delaware. (Delaware Public Archives, State Board of Agriculture Photographs, Negative 1099.)

DuPonts in Dover, 1924. Coleman DuPont and family are pictured on the State House steps at ceremony marking the opening of the DuPont Highway, on July 2, 1924. The opening of the DuPont Highway was cause for celebration in Dover, and the day was marked with a parade around the Green. DuPont was a favorite son of Dover's citizens for ensuring that the highway was built through town. (Delaware Public Archives, State Board of Agriculture Photographs, Negative 183.)

An Official State Vehicle, 1924. Old Studebaker Automobile used by W.W. Mack of the State Highway Commission, June 6, 1924. (Delaware Public Archives, State Board of Agriculture Photographs, Negative 167.)

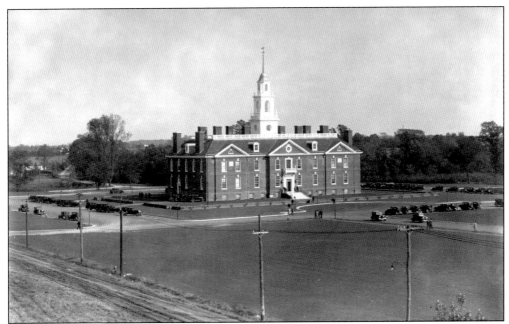

LEGISLATIVE HALL, OCTOBER 19, 1933. Plans for a new home for Delaware's legislature finally came to fruition in the 1930s with the opening of Legislative Hall, just east of the The Green. The Legislature was previously located in the Old State House on The Green. (Delaware Public Archives, State Board of Agriculture Photographs, Negative 1877.)

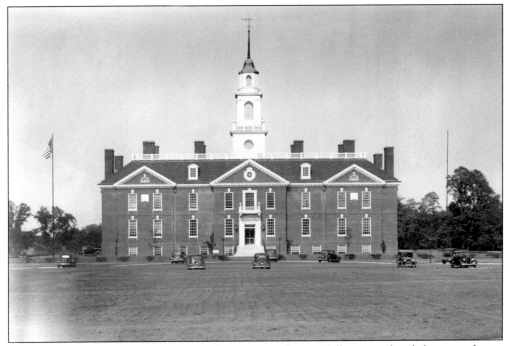

LEGISLATIVE HALL, MAY 12, 1936. The new Legislative Hall is considered the seat of state government and anchors the eastern end of Legislative Mall. (Delaware Public Archives, State Board of Agriculture Photographs, Negative 1876.)

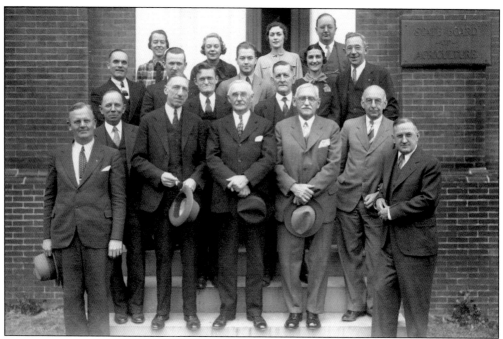

STATE BOARD OF AGRICULTURE AND STAFF MEMBERS, DECEMBER 21, 1936. The State Board of Agriculture was directly responsible for one of the state's most valuable collection of photographic materials. Many of the photographs in this book are the result of a photographer hired by the Board of Agriculture to gather photographs of agricultural production in Delaware. (Delaware Public Archives, State Board of Agriculture Photographs, Negative 1899.)

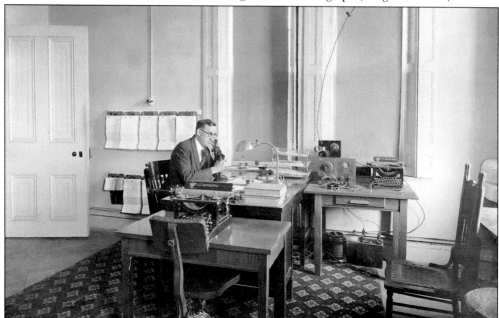

A MODERN OFFICE, 1923. An office worker is pictured in the new office of the Bureau of Markets in the Department of Agriculture, surrounded by all the trappings of modern office equipment. (Delaware Public Archives, State Board of Agriculture Photographs, Negative 42.)

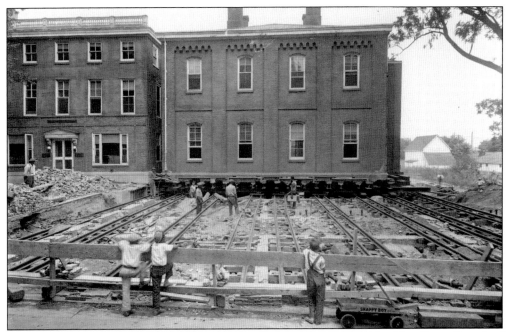

STATE BOARD OF AGRICULTURE BUILDING BEING MOVED, 1932. The State Board of Agriculture building was moved from its original location next to the State House to a new position just north of the State House. The move allowed for an open vista from the Green to the new Legislative Hall. The boy on the right has a "Snappy Boy" wagon parked next to him. July 16, 1932. (Delaware Public Archives, State Board of Agriculture Photographs, Negative 1990.)

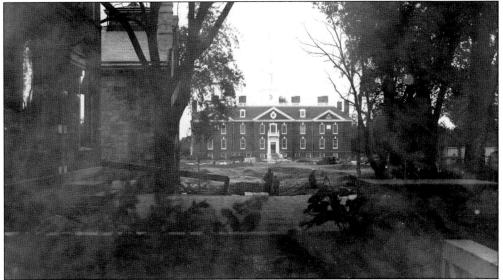

NEW VISTA TO LEGISLATIVE HALL, OCTOBER 25, 1932. Once the Agriculture building was moved, a new vista of Legislative Hall was opened. This area initially contained a paved road which provided access to The Green from the newly developing east side of Dover. That road has since been abolished and the area is now an open space. (Delaware Public Archives, State Board of Agriculture Photographs, Negative 1973.)

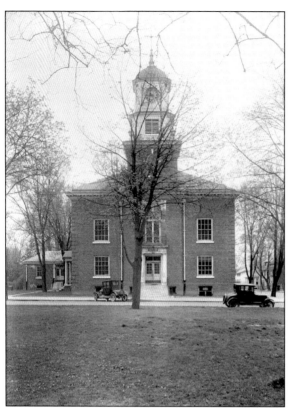

KENT COUNTY COURTHOUSE, APRIL 23, 1926. The Kent County Courthouse, located on The Green, remains the primary office for all county-related court matters. (Delaware Public Archives, State Board of Agriculture Photographs, Negative 498.)

DOVER ARMORY, AUGUST 2, 1929. The Dover Armory stands on the southwest side of Legislative Hall on the Legislative Green. (Delaware Public Archives, State Board of Agriculture Photographs, Negative 1003.)

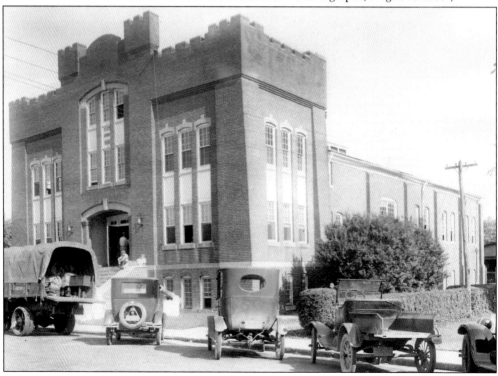

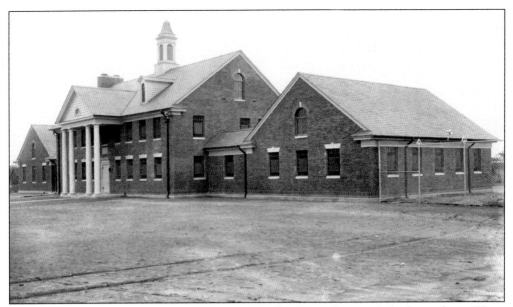

KENT COUNTY JAIL, NOVEMBER 12, 1932. The Kent County Jail—located on Water Street in Dover—was later renamed the Morris Correctional Facility and currently serves as a minimum security prison. (Delaware Public Archives, State Board of Agriculture Photographs, Negative 1565.)

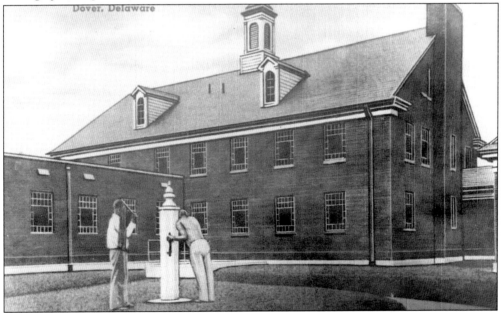

DELAWARE WHIPPING POST, C. 1930. This architect's rendering of a whipping post built for the new Kent County Jail shows how the post would be used. This brutal form of corporal punishment was first used in Delaware in 1717. It was restored in 1930 and moved to the newly built Kent County Jail. The 1915-revised code set a specific number of lashes for each crime. Wife beating and assault each resulted in 30 lashes, while 60 lashes were handed out for poisoning with intent to murder or burning a courthouse or place of record. (Delaware Public Archives, Purnell Photograph Collection, Box 3 Folder 2.)

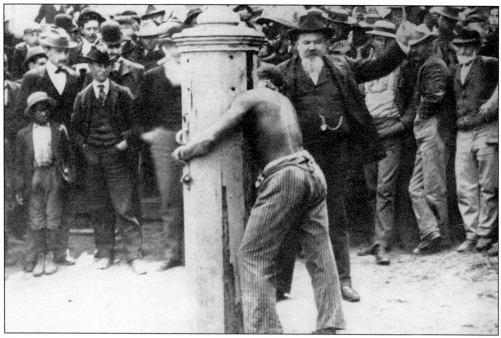

THE DELAWARE WHIPPING POST, C. 1930. These compelling images of corporal punishment in Delaware depict what one newspaper of the time called "the shocking barbarity" of Delaware's whipping post. (Delaware Public Archives, Purnell Photograph Collection, Box 3 Folder 2.)

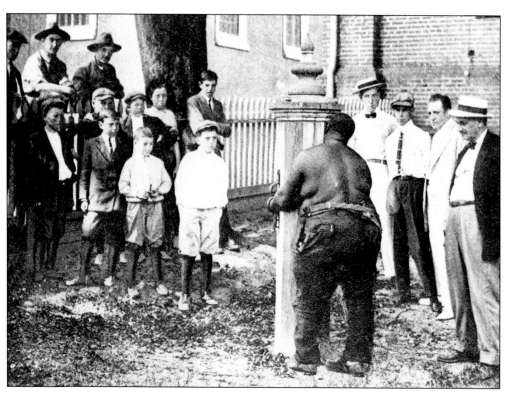